NEWCASTLE
THROUGH TIME

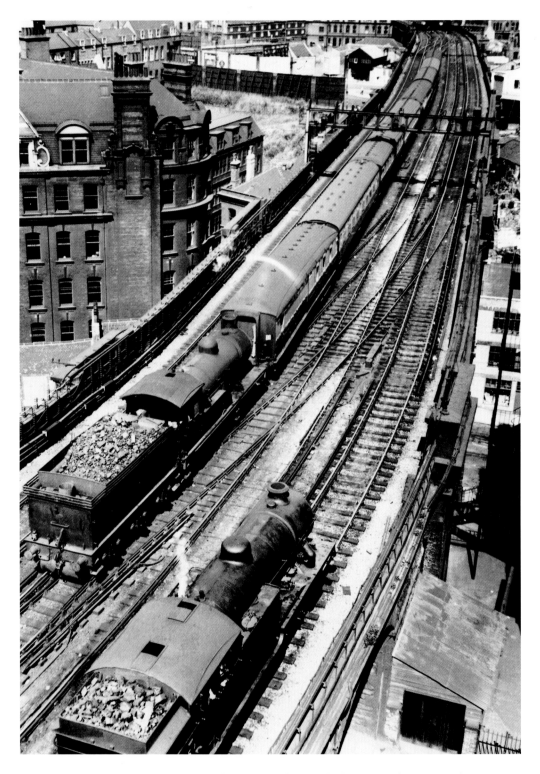

Trains on the East Coast Main Line, seen from the Castle Keep, looking towards Manors. The train is crossing Dean Street Bridge.

NEWCASTLE
THROUGH TIME

JOHN CARLSON AND JOYCE CARLSON

AMBERLEY PUBLISHING

Dedication

This book is dedicated to the patrons of the Barley Mow.

First published 2009

Amberley Publishing
Cirencester Road, Chalford,
Stroud, Gloucestershire, GL6 8PE

www.amberley-books.com

British Library Cataloguing in Publication Data.
A catalogue record for this book is available from the British Library.

ISBN 978 1 84868 168 2

Typesetting and Origination by Amberley Publishing.
Printed in Great Britain.

Contents

Acknowledgements

I would like to acknowledge, in no particular order, the help and inspiration of Davit Roberkidze, Howard Goldsborough, Stuart Smith, Neil Tweddell, Beamish Open Air Museum, Neil Mortson, Mike Taplin, Tony Walmsley, Nexus David Packer, Alan Thompson, Bob Payne, the Tanfield Railway, Ron Fisher and the National Tramway museum.

Introduction

I am a Georgian who has come to love this city. When I was in Georgia, on the other side of the then Berlin Wall, I saw Newcastle occasionally on TV and, to be honest, I was not that impressed. Things were different back then. Many years later, by a series of happy and not-so-happy accidents, I moved across Europe, then to London and eventually Newcastle. After I collected my keys and moved into my flat in the city centre, I found time to look around and I was impressed. There are not many views in the UK that rival the Tyne and its bridges.

Around 1895, a city guide trumpeted its achievements and set the scene for visitors; 'Newcastle-upon-Tyne is acknowledged to be one of the most prosperous and rapidly increasing of the large towns of England. It is situated at the southern extremity of the county of Northumberland, on the north side of the Tyne, nearly ten miles west of the German Ocean, 56 miles east of Carlisle, 117 miles south-east of Edinburgh, and 273 north, north-west of London. Such has been the rapidity of its progress, that while the general increase of the population of the kingdom since the commencement of the present century, has but doubled itself, Newcastle has trebled its population, and more than trebled the number of its dwelling-houses during the same period.'

That was a Newcastle that was increasingly rapidly thanks to industry and the railways, railways that were making it possible for the poor, as well as the wealthy, to move around the country in increasing numbers. Now Easyjet and Ryanair are making it possible for people to move around Europe in increasing numbers.

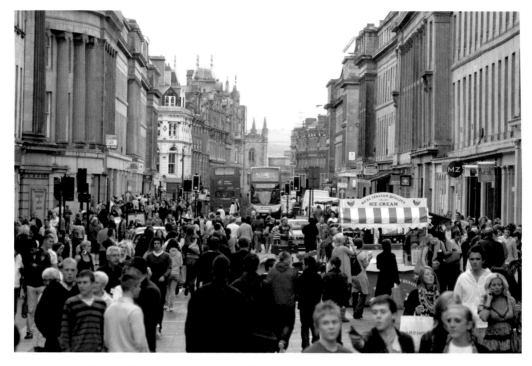

Looking along Granger Street towards the Central Station in late 2007.

One only has to walk around the city centre to see how cosmopolitan it has become.

Today, Wikipedia is a good place to start when looking for information on the city. It remarks that, 'Newcastle is perceived as a working class city, with a smaller middle class population than the UK average. Among its main icons are Newcastle Brown Ale, Newcastle United and the Tyne Bridge. It grew as an important centre for the wool trade and later became a major coal mining area. These industries have since experienced severe decline and closure, and the city today is largely a business and cultural centre, with a particular reputation for nightlife.'

And me? I'm proud to be a Georgian living in Geordie Land. I love Newcastle. It's full of people enjoying life. I think this is one of the best cities to grow up in and raise a family. There is a certain rough-and-ready quality to the people of this city, but I found once I got used to them, I loved them.

Davit Roberkidze, January 2009

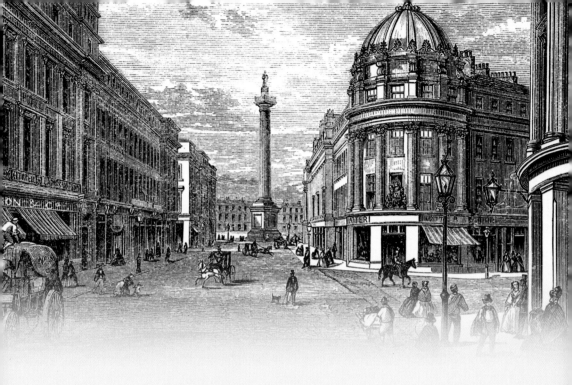

chapter 1

From the Monument

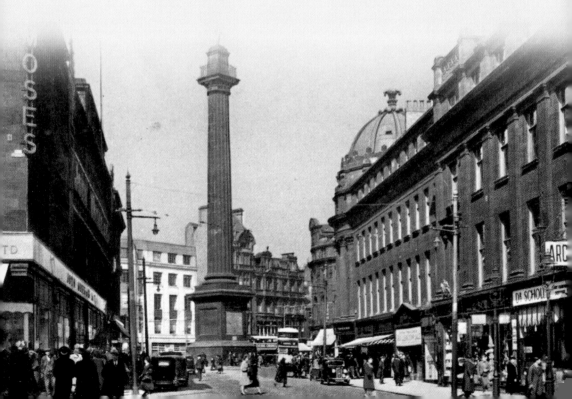

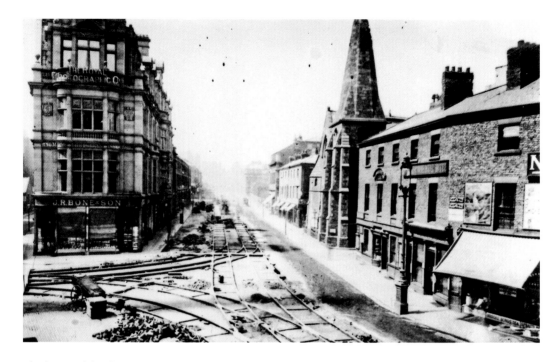

The laying of the electric tramway tracks around the Monument area, *c.*1900, and a colourful postcard image of roughly the same area a few years later. The YMCA building (left) is present in both pictures. A Presbyterian church, believed to be built in 1821, has been superseded by the magnificent Emerson Chambers of 1903. Electric trams, in this case an F class tram, are now on the scene and mark progress in the city.

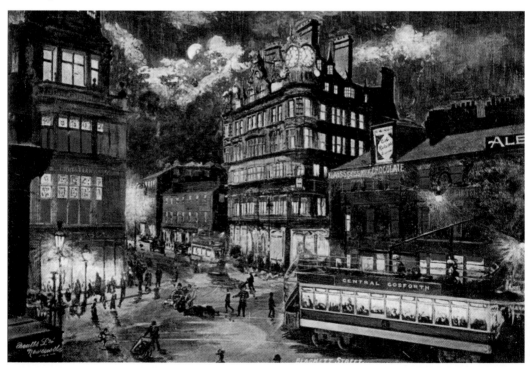

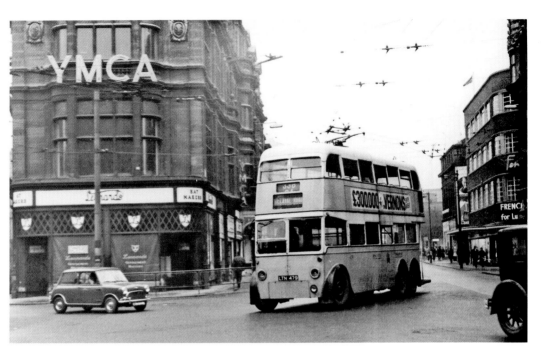

We move to the early to mid-1960s. Both the trolleybus and the YMCA building are about to disappear into history as ideas ferment for demolishing and rebuilding almost all of this area. The trolleybus is framed by a mini, an icon of another age, and there is a tantalising glimpse of a vintage car to the right. Below, modern day Newcastle never became the city that the sixties planners dreamed of, but in evidence here are the more environmentally friendly Enviro 400 diesel bus, the Metro and a sparkling entrance to Eldon Square. What at least one seventies sociologist called 'a temple of consumption', has replaced the YMCA (S. Smith collection).

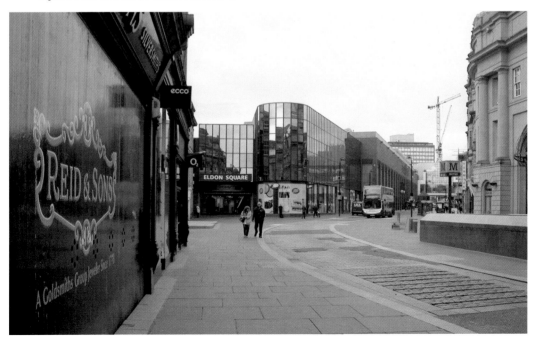

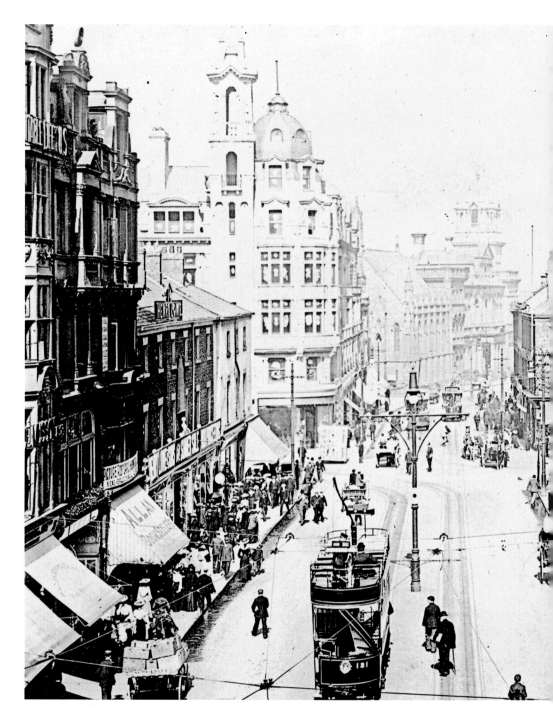

Blackett Street from Grey's Monument. Magnificent, and at that time modern, structures are rising out from the more mundane brick buildings. G.S. Hearse wrote in his book *The Tramways of Gateshead* that the Tyneside of that time was 'looked on by the engineer as the Mohammedan looks upon Mecca'. A war, a depression and then another war would slow that progress considerably. The First World War was to smash trade patterns as thoroughly as lives, and, arguably, it took Tyneside until the end of the twentieth century to recover to the level of progress seen above. At the time of writing the

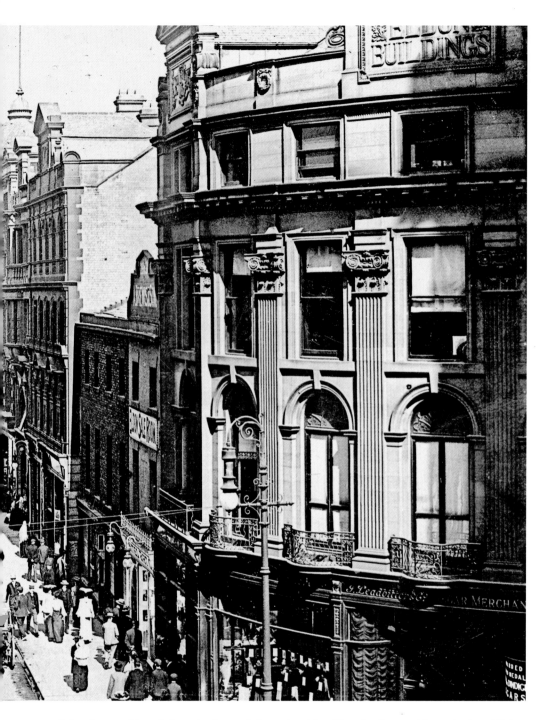

words 'credit crunch' are being edged out of the national headlines by the word 'recession', and Prime Minister Gordon Brown has made the slip of describing the world economy as being in depression. However, the modern day photographer standing on the top of Grey's Monument would be able to see cranes working all around him as building and rebuilding takes place on Eldon Square, the new library, both universities and Haymarket Metro Station. And the streets below would still be packed with purchasers.

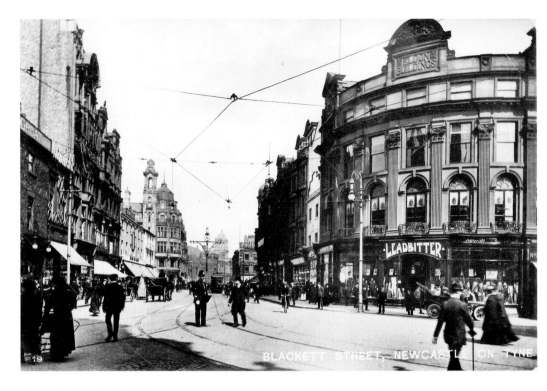

Above, the bustle of Blackett Street c.1905. By the time of the 'between the wars' image below, the motor car is in the ascendency and pedestrians have retreated to the pavement. The word pedestrian derives from the Latin *pedester*, meaning 'going on foot'. During the eighteenth and nineteenth centuries, pedestrianism was a popular spectator sport.

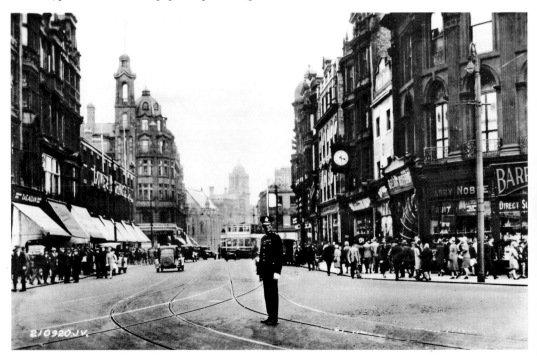

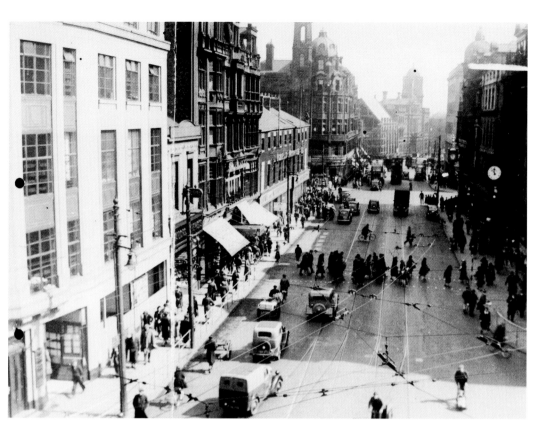

Motor traffic is now dominant and trams are still in evidence but so now is the (then progressive) double wire 'trackless tram' – the trolleybus. A designated pedestrian crossing is visible with its cluster of pedestrians. The new post office building on the left is rather modern; it has big, functional windows, denoting a less formal way of working and doing business. Below, Blackett Street is seen from the Eldon Square entrance in 2008 (courtesy S. Smith.)

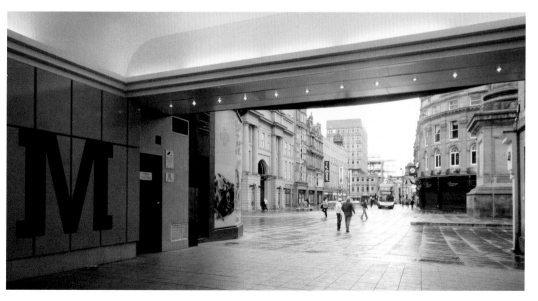

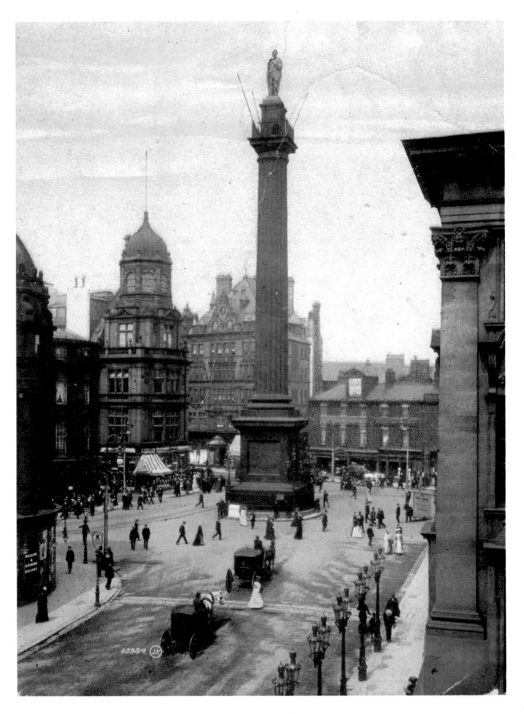

Built in 1838, Grey's Monument is Grade I listed and dedicated to Charles Grey for the passing of the Great Reform Act of 1832. The column was designed by local architects John and Benjamin Green, and the statue of Grey was created by the sculptor Edward Hodges Baily. In 1889 a town guide remarked that 'as the monument greatly impedes the traffic of this crowded thoroughfare it is probable that it may be necessary, 'ere long to remove it to a more open space'.

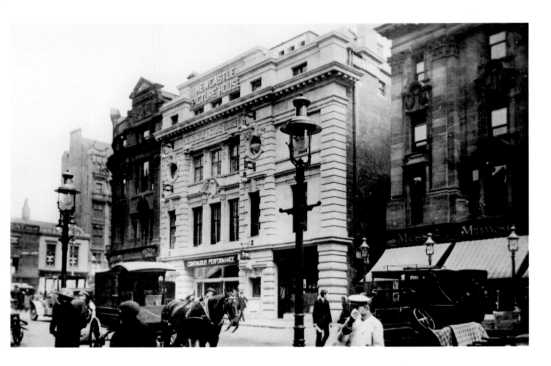

It came as a surprise, when researching this book, to find that some familiar structures in Newcastle today existed in radically different guises in the past. One of the magnificent buildings still at Grey's Monument is the Newcastle Picture House, the ground floor of which is now a bank and scarcely recognisable as the same building – particularly at night, due to its lighting tubes. Another is the Eldon Building, now seeing service as The Eldon Grill.

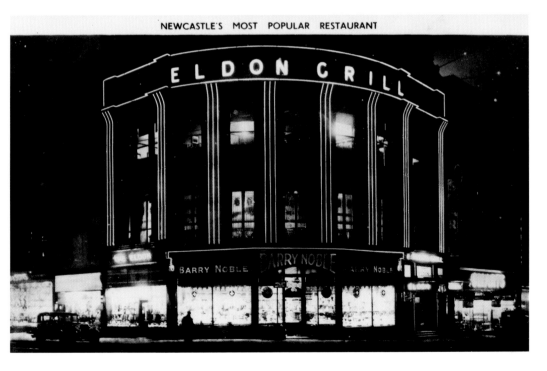

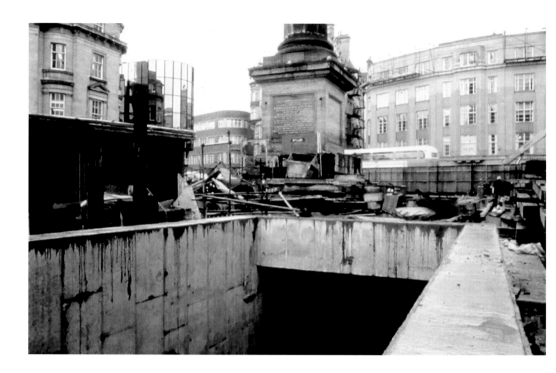

One of the biggest upheavals at Grey's Monument was the near the construction of Eldon Square and the Monument Metro Station. These pictures show some of the work in progress on construction of the metro station and the fitting out of one of the platforms. Transport enthusiast Tony Walmsley writes that 'in 1981, our University Transport group paid a visit to the Tyne and Wear Metro system'.

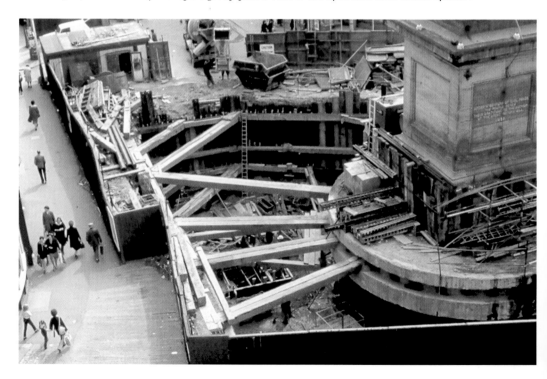

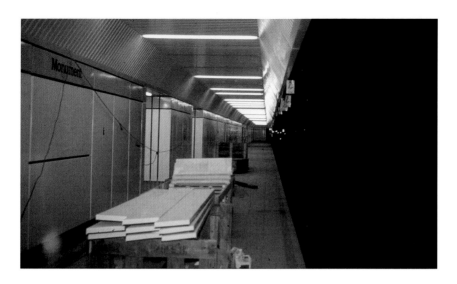

At that time, the only section operating was between Haymarket and the coast along the north loop through Benton. Apparently, when excavating this station underneath Grey's Monument it was discovered that the column had been built on foundations less than 2m deep. The Monument is 41m tall, and these insignificant foundations gave the metro engineers a lot to worry about – they had to provide much more significant support for Grey's Monument while building the station caverns underneath! It is amazing that the Monument remained standing for over 140 years before the metro work, particularly as it had tram then trolleybus wires attached to it. Indeed, as the trolleybus system contracted, the wires were only attached to about 1/4 of the quadrant of the tower. The tension must have been quite something! (Pictures courtesy Nexus (opposite page) and Tony Walmsley (this page.) Below, a Tyne and Wear PTE bus in Blackett Street. An integral part of the metro scheme was its integration with local bus services.

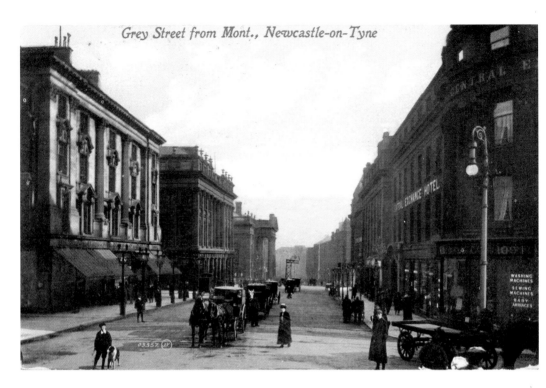

Looking south and north along Grey Street. Grey Street is renowned for its Georgian architecture, and has been voted 'Best Street in the UK' by BBC Radio 4 listeners. An 1889 guide described it as 'the handsomest Street in the city and few streets in any town or city in the empire can vie with it'.

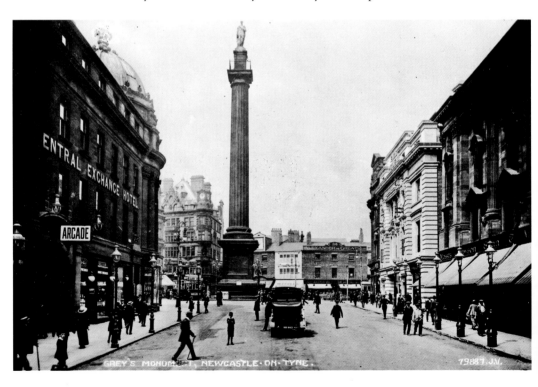

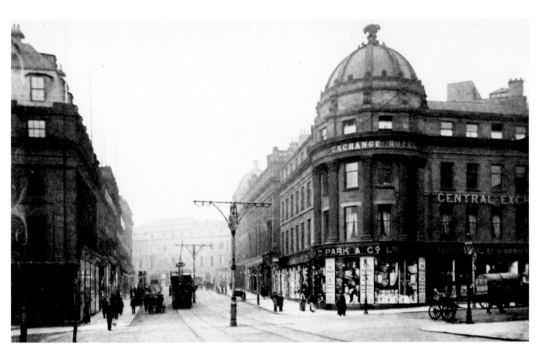

Market Street, *c.*1906. The Central Arcade Exchange was originally designed as a commercial exchange and newsroom. An 1889 guide recounts how part of the design is influenced by the Temple of Vesta in Italy. Richard Granger offered to make a present of this building to the Newcastle Corporation if they would devote it to the purpose he intended. They declined and he fitted it up as a newsroom and general exchange (images courtesy S. Smith collection).

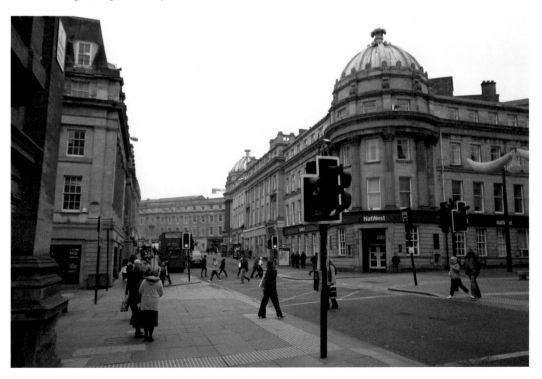

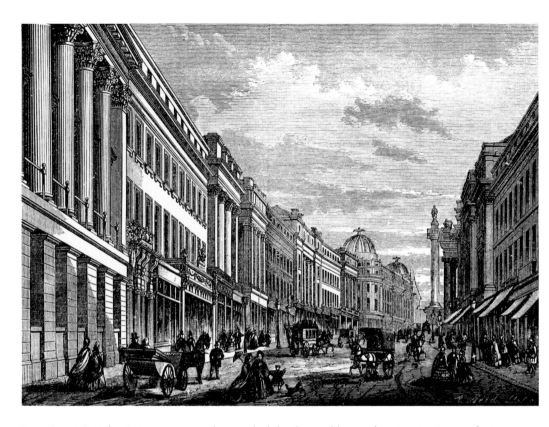

Dean Street. Sir John Betjeman apparently remarked that he would never forget seeing it to perfection, traffic-less on a misty Sunday morning and that not even Regent Street, in London, could compare with 'that descending subtle curve'.

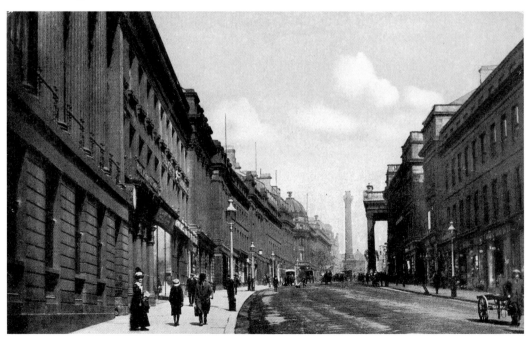

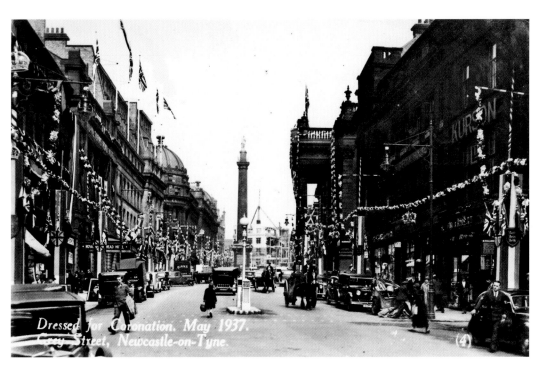

Grey Street, dressed out for the 1937 coronation. The building's surfaces are now very blackened. Below, an early 2009 view. The area has been somewhat reinvigorated of late and is now home to several popular bars.

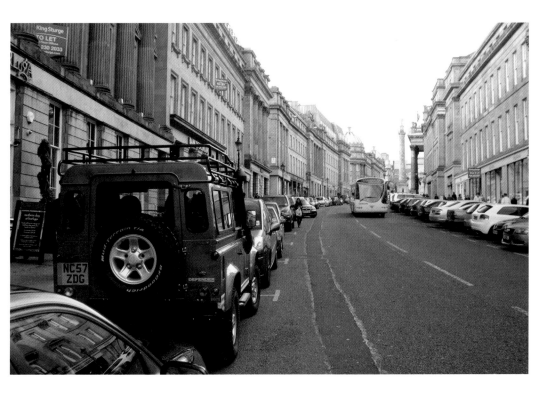

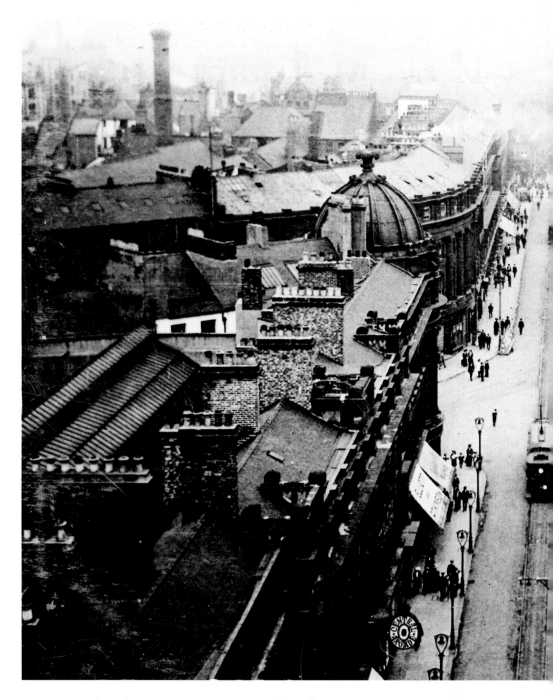

Granger Street from the Grey's Monument, c.1906. The traffic seems to consist entirely of trams and pedestrians. Horse trams ran in the city from 1879. The 17 miles of route, built from 1878 onwards, were leased to the Newcastle and Gosforth Tramways and Carriage Company Ltd., which worked them with a maximum of forty-four horse trams and also (initially) four steam tramway engines. The lease expired in 1899 and the Newcastle Corporation took over and electrified the system between 1901-4. Horse tram services ceased on 13 April 1901, and the new electric cars ran from 16 December 1901. The corporation opened nearly twenty extensions up to 1928, bringing the route mileage up to just over

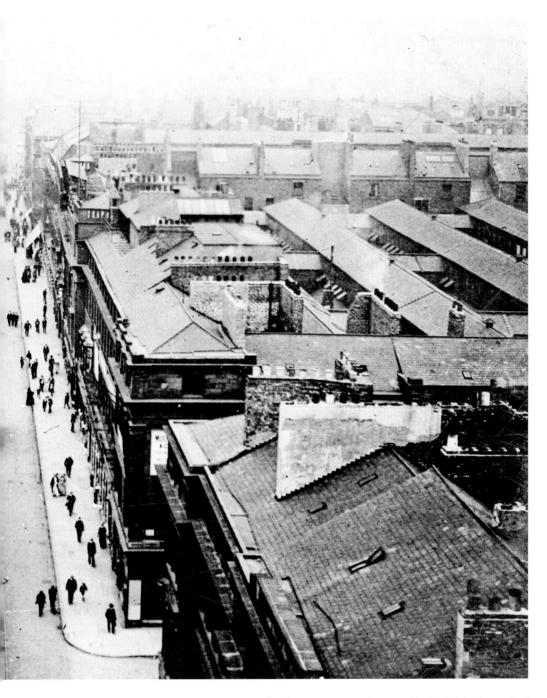

fifty-one. Newcastle Corporation's trams ceased running on 4 March 1950. To the left is the roof of Central Arcade. Today it is well known as the home of J.G. Windows, one the UK's oldest music stores which celebrated its one hundred year anniversary in 2008. The structures in the top left-hand corner were home to Bainbridge's department store. The façade remains today, but the interior was much rebuilt in the twentieth century and then completely torn down and rebuilt towards the century's end. The Granger Market is visible to the right (image courtesy S. Smith collection).

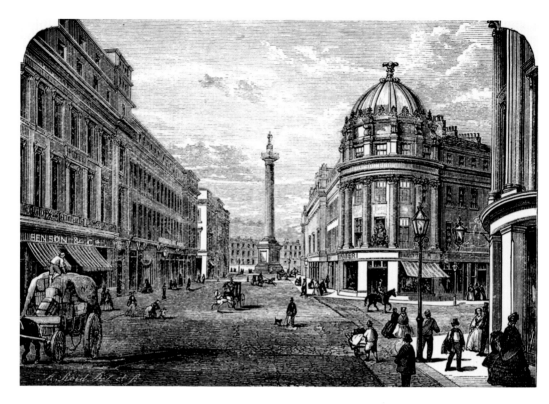

Views of Grey's Monument from Grainger Street. Richard Grainger was said to 'have found Newcastle of bricks and timber and left it in stone'. Today this area is largely pedestrianised. It has been estimated that in five years Grainger added about a million pounds to the value of the city centre. He also often employed up to two thousand workmen at a time.

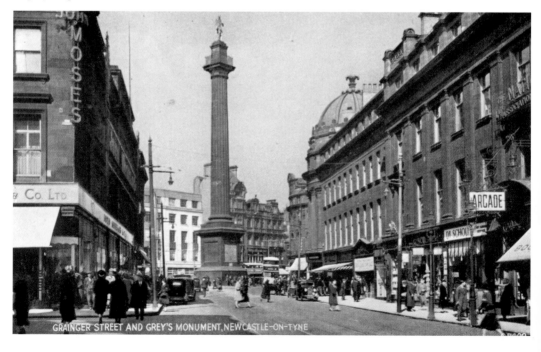

GRAINGER STREET AND GREY'S MONUMENT, NEWCASTLE-ON-TYNE

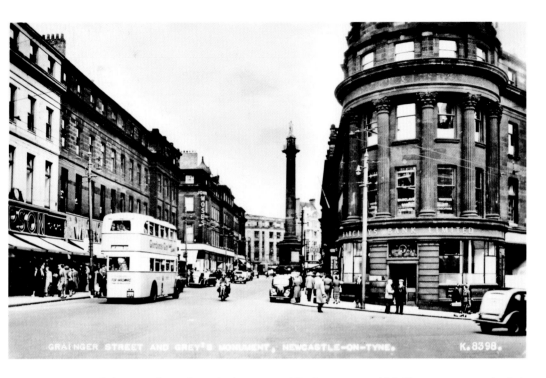

Views around the central arcade in the late 1950s. T.P. Canneaux and N. Hanson comment in their book *The Trolleybuses of Newcastle upon Tyne* that 'trolleybus overhead wiring was preset for them to run along market street and the conductor for any bus heading for the Monument would have to jump off at this junction, pull the leaver to change the overhead frog and then would come the sound of him banging on the side of the bus with his hand to inform the driver he had reborded. At the Monument the wiring arrangement is very complicated and the criss-cross of overhead hangs heavy in the sky'.

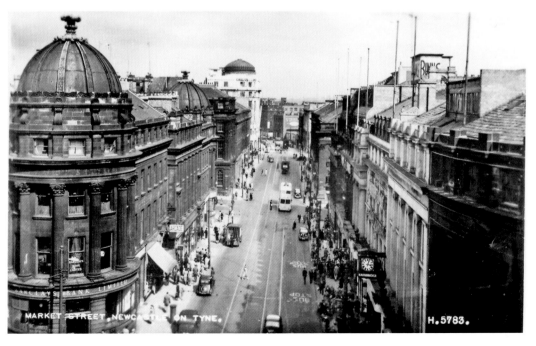

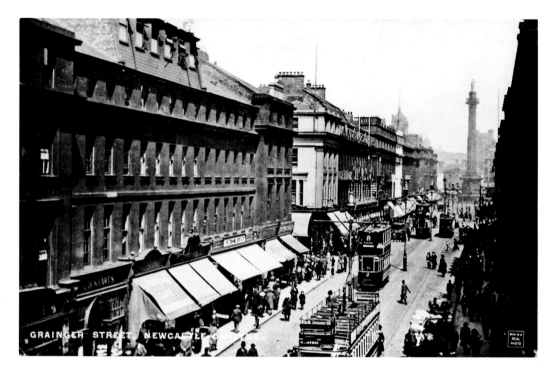

Above, looking along Grainger Street. Below, Gateshead & District Tramways Co. car No. 31 in Grainger Street. The car's look is strangely incongruous with the tailors' premises behind. After Newcastle Corporation terminated its tram services in 1950, the Gateshead and District continued running its cars through the city centre, operating over corporation tracks until 4 August 1951.

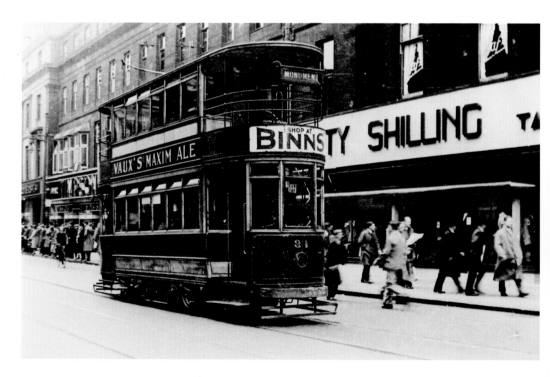

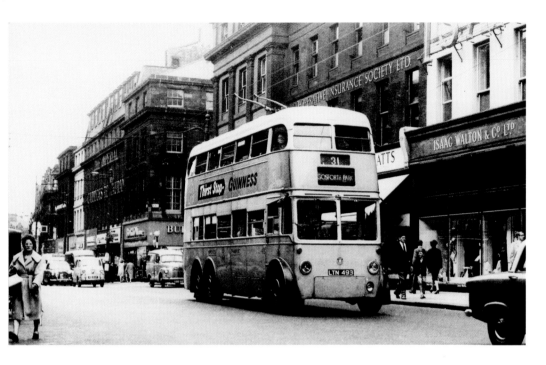

One of the corporation's trolleybuses on Grainger Street, this was one of the Q1 class originally intended for London transport. The city's trolleybus system ran from 1935-1966, serving the it for thirty-one years. The last trolleybus was scheduled to have been 628, the highest numbered trolleybus. However, the last into the depot was 599, which had been delayed by enthusiasts taking photographs. Electric buses of a hybrid type returned to Newcastle with the Quaylink bus service which features ten vehicles costing £250,000 each. The service's original, very low ridership has since significantly improved the service has been extended and the hybrids have been supplemented by a number of rather old ex-South Shields diesel buses, painted yellow.

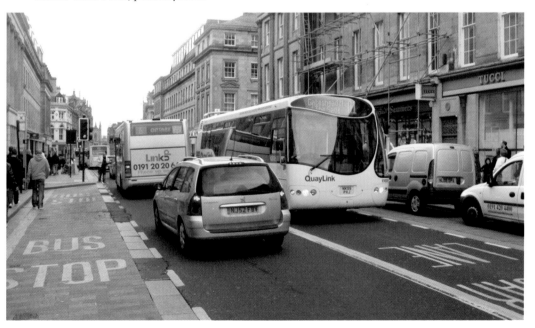

The junction of Newgate Street, Grainger Street and The Bigg Market. The once polished stone of Grainger's constructions is now looking a little grimy. The buildings to the right concealed much of the former Bainbridge's department store which around this time was billing itself as 'One of the Sites of Newcastle. . . certainly worthy of your visit'. It continued, 'An excellent Restaurant and Tea rooms with an Orchestra offer you refreshment and entertainment, and you are at liberty to stroll round this modern department store with the full knowledge that you will not be asked to buy'.

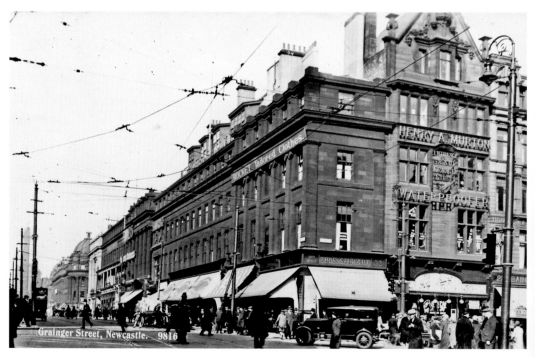

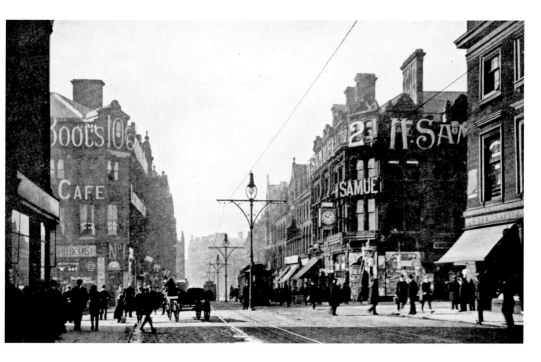

Grainger Street looking towards the Central Station, above c.1905 and below February 2009. If Granger was to walk down his namesake street which view would he prefer? We might view the 1905 advertising as quaint or striking but would he see it as a disfigurement? Would he be pleased his buildings had survived or wonder why we had not got around to sweeping them away and replacing them with something more modern?

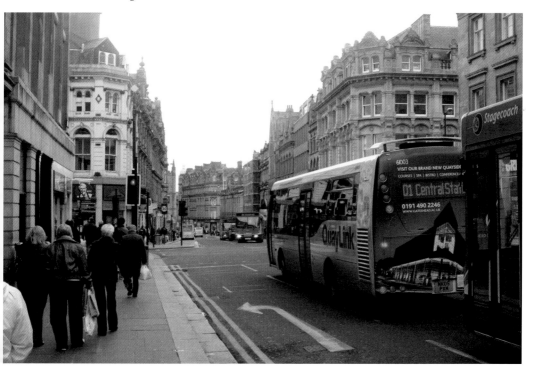

Above, The Bigg Market c.1905. The 1889 town guide commented 'At present, in the big market a market for provisions is held on the mornings of Thursday and Saturday. The articles sold are butter, bacon, eggs, rabbits and poultry. They are brought in by the carrier's carts, which arrive from all parts of the surrounding country on the mornings of these days and return in the afternoon to their several destinations, laden with groceries and other goods purchased in the town.' Below, a similar view c.1950.

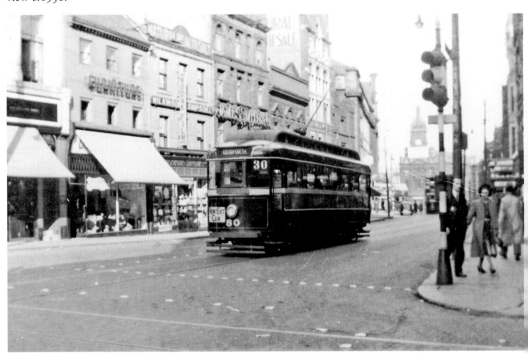

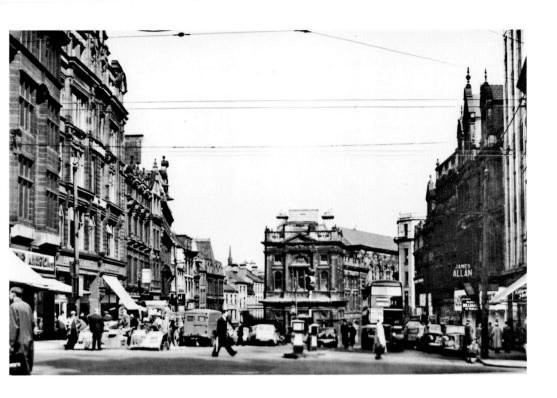

A view of the Bigg Market with the old town hall clearly in view. This image is likely to have been taken around the end of the 1950s. Today, The Bigg Market is a popular drinking spot, almost internationally synonymous with half-clothed people staggering around drunk, being sick and shouting loudly. The down-side is that this has pushed up prices somewhat.

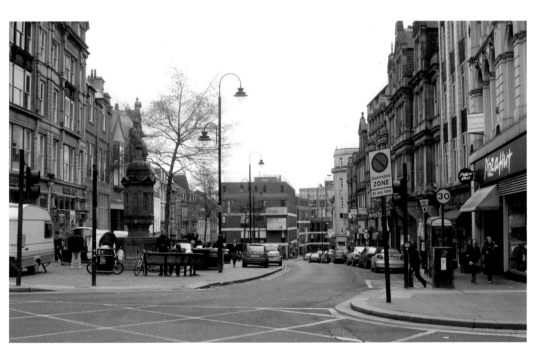

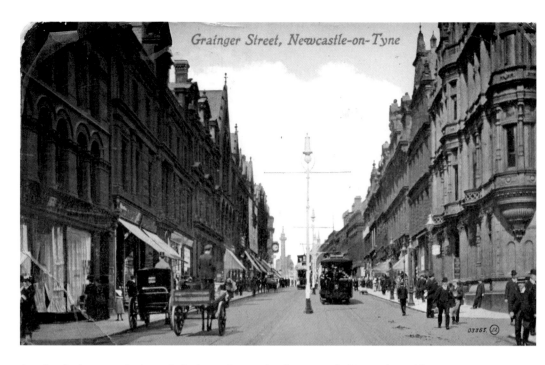

Grainger Street, Newcastle-on-Tyne

A colourised postcard view of Grainger Street. At the time of this card's publication, tramway and electric public lighting infrastructure represented colossal progress in the city and were often deliberately highlighted by the photographer. It is possible to find instances where artists have even touched up the overhead wires to increase their predominance. A few decades later the wires would be seen as unsightly. By late last century, this area was becoming a little rundown but has been largely revived by the Grainger Town Project. Below you can see the view today.

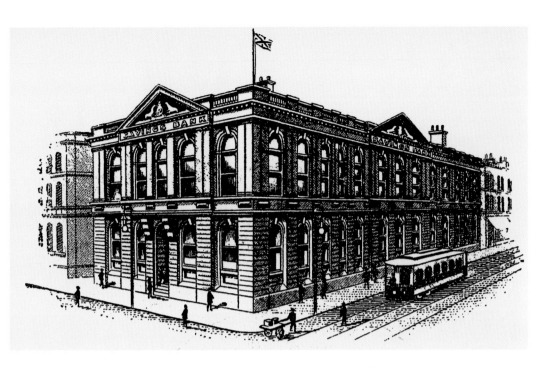

An illustration of the Savings Bank of Newcastle's head office on the corner of Westgate Road and Grainger Street. In spite of its rather old look it was published in 1928 with the strap line 'older than the oldest of our bridges and stronger than the strongest', which was a reference to the then current opening of the Tyne Bridge. The advertisement added that it held 78, 000 accounts with total funds of over three and a half million pounds. Below, around 2001 much of the building became unstable and the metro had to be shut down in the Central Station area to avoid it collapsing into the street. The picture below shows it supported by scaffolding some time later.

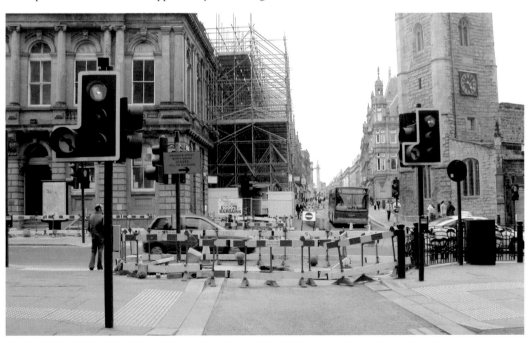

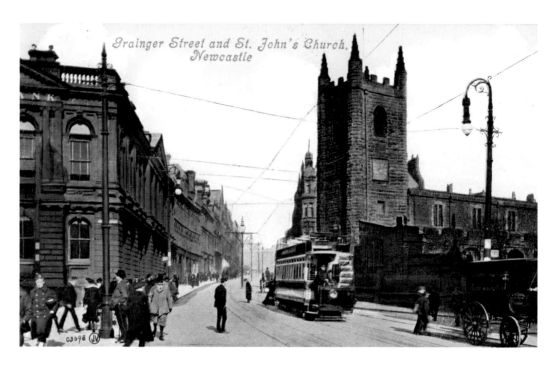

Postcard views of the junction between Grainger Street and Westgate Road with the Church of St John the Baptist on the right. The church was built in the thirteenth century and the pinnacled tower added some two hundred years later. It has been described in local tracts as 'a large cruciform structure, probably of the age of Edward I, and chiefly of the early English character but greatly affected by comparatively modern alterations and enlargements... surmounted by a quadrangular embattled tower, and contains a font venerable for its antiquity, several ancient monuments, an altar piece, and a painted window, by Mr. Gibson, of Newcastle'.

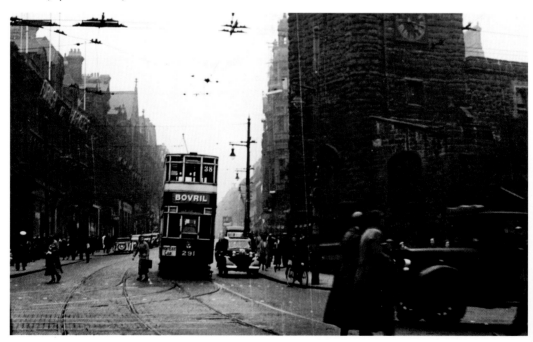

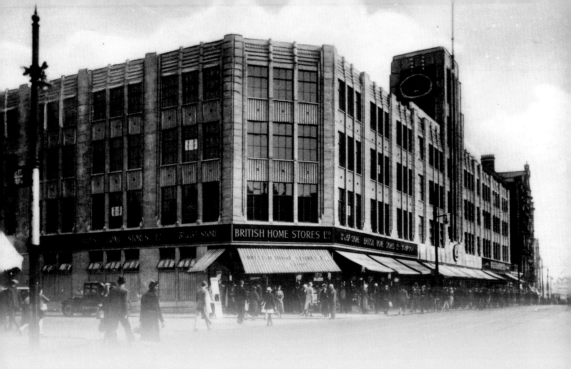

chapter 2

Northumberland Street

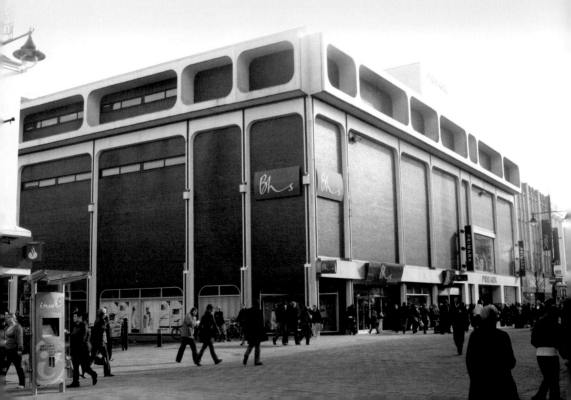

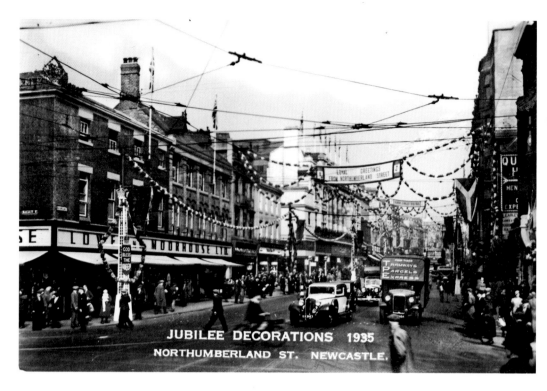

JUBILEE DECORATIONS 1935
NORTHUMBERLAND ST. NEWCASTLE.

Northumberland Street, 1935. In Newcastle we believe there were attempts to sign the legendary footballer Stanley Matthews in this year. On the left of the image the premises of Lowe and Moorhouse are visible. In the image below the building has been replaced and a much larger and more modern building has arrived. This seems to have spent most of its life in use as a clothing retailer being used

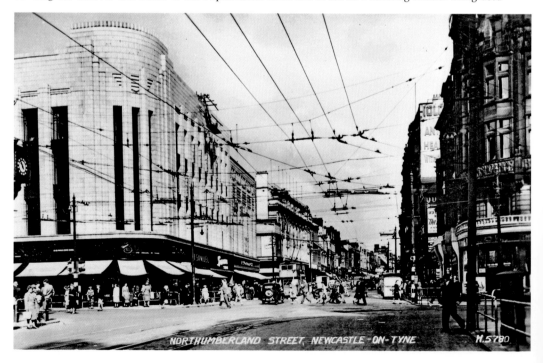

NORTHUMBERLAND STREET, NEWCASTLE-ON-TYNE. M.5790

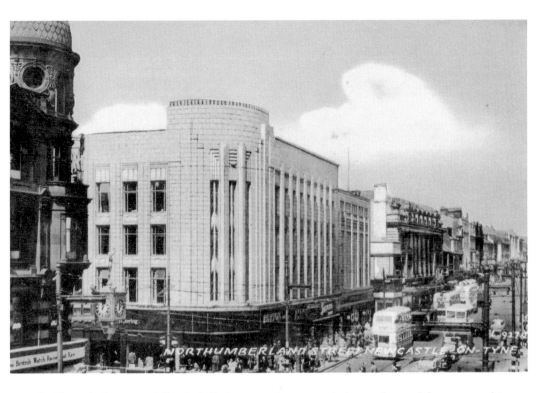

by Kenneth Cross, specialists in ladies' coats, suits, gowns, knitwear, furs and fur coats, and it was later occupied by Burton's. Today it is the site of the Monument Mall. In the last image, traffic on Northumberland Street has been cut back to just buses and delivery vehicles.

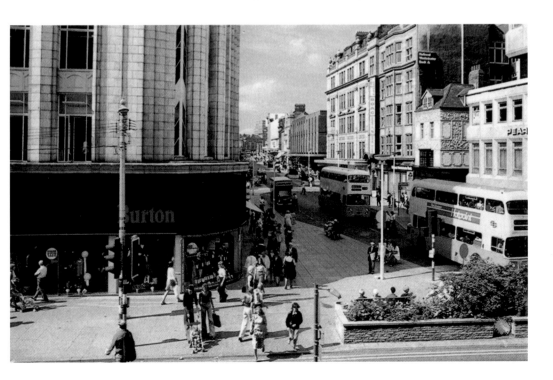

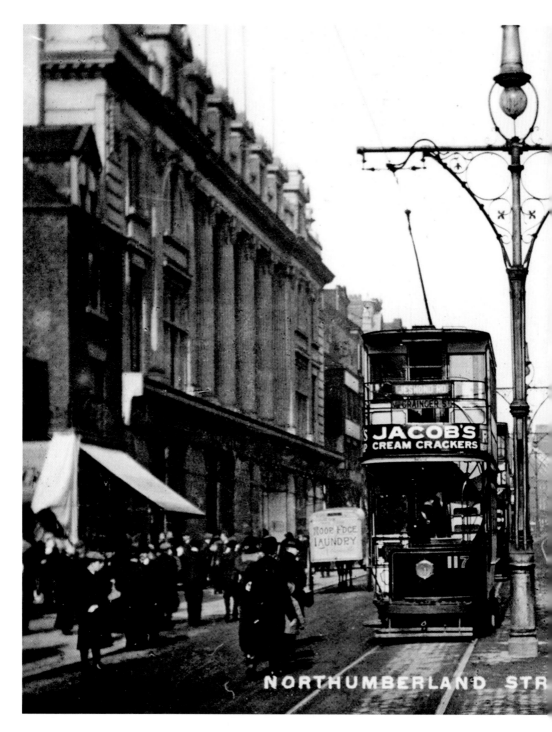

An impressive postcard image of Northumberland Street *c.*1908. It is interesting to note the prominence the photographer has given to an electric lamppost. Oil lamps were introduced to the streets of Newcastle in 1763, but they were not lit on nights when the moon was expected to shine. By the time this photograph was taken, the Newcastle and District Electric Lighting Company (DISCo) would have been supplying electricity to the area of the city west of Grainger Street. They were apparently the first

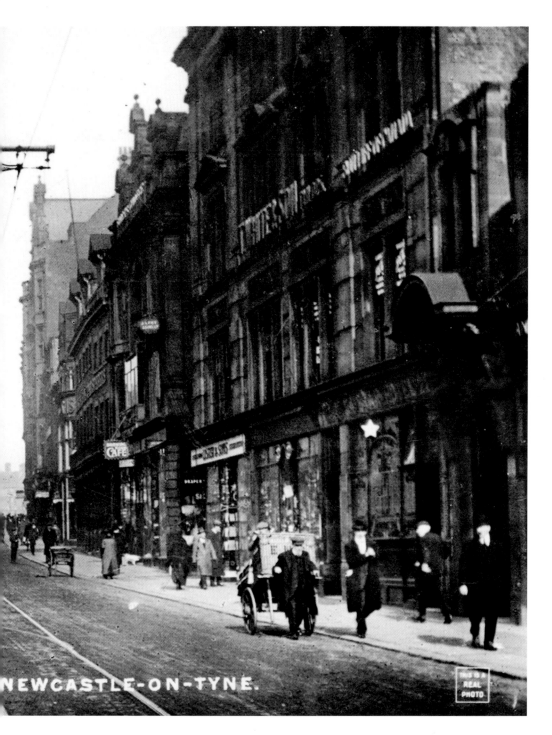

NEWCASTLE-ON-TYNE.

company in the world to generate electricity using turbo generators. The supply to Northumberland Street would probably have been provided by the Newcastle-upon-Tyne Electric Supply Company. This was founded in 1889 by the industrialist John Theodore Merz who built a series of coal-fired power stations in the area. Both companies were merged into the North Eastern Electricity Board on the nationalisation of the industry in 1948.

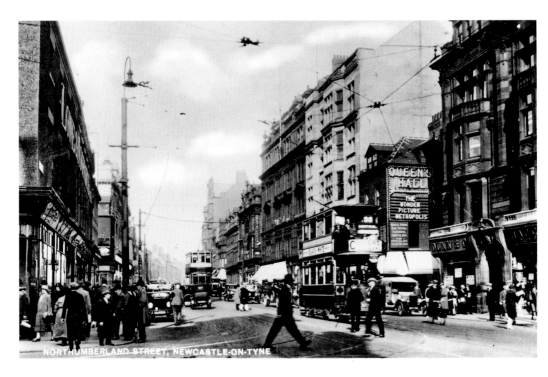

Northumberland Street with and without traffic. A sign of the times in the lower picture is an information point provided by the council. The rumble and clank of trams has long been a thing of the past, but the area in the centre of the photograph is often used by salesmen proclaiming their wares, often to loud musical accompaniment.

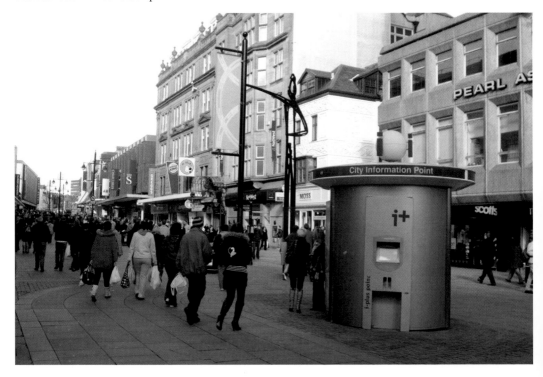

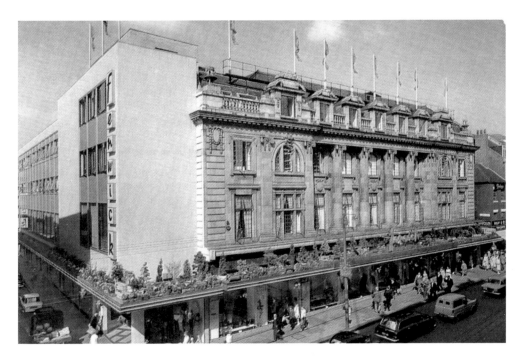

The Northumberland Street frontage of Fenwick's department store. This has been rebuilt and extended over the years but in a manner so sympathetic with the original that we doubt most people would be immediately aware of the additions.

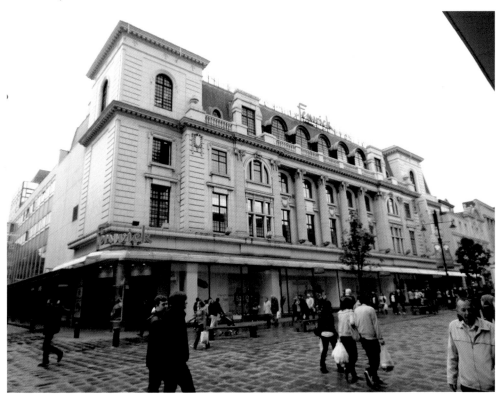

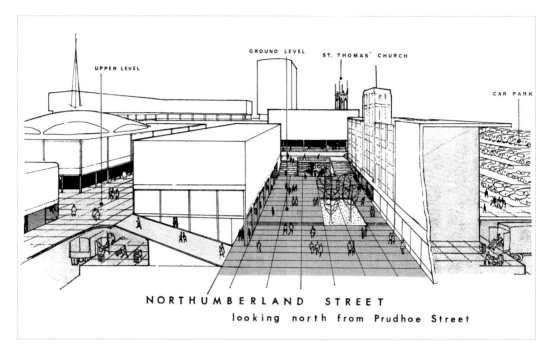

NORTHUMBERLAND STREET
looking north from Prudhoe Street

Above is an illustration of what could have been in Newcastle, in this case Northumberland Street looking towards the Haymarket. We can assume that the large structure in the left foreground is now the building largely occupied by Marks and Spencer. Strangely, the former C&A building seems projected to have been a survivor of this reconstruction.

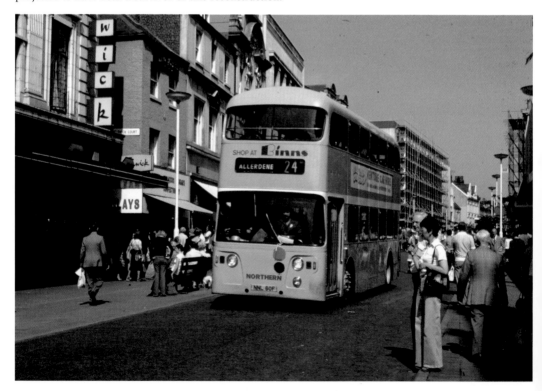

A once prominent name on Northumberland Street was that of Callers, a furniture store. As well as furniture there was a selection of electrical goods and a large record department that seemed able to beat many of the more prominent music chains on price. When the shop closed two of the staff members founded a shop called Hitsville USA in premises just around the corner. The Callers name lives on, however, as part of the Callers Pegasus travel agency. Below, a corporation bus on service 8 at the top of Northumberland Street. This was pretty much the last section of Northumberland Street to be pedestrianised. The buildings visible here have largely survived although the area itself has seen considerable rebuilding.

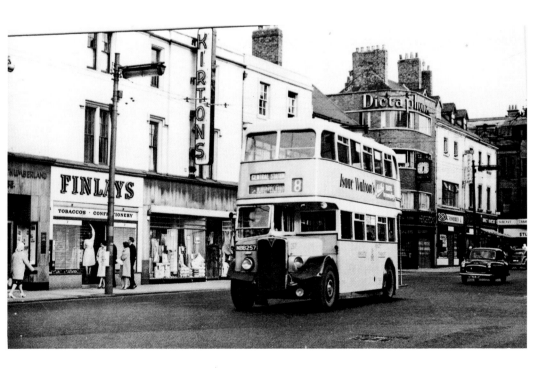

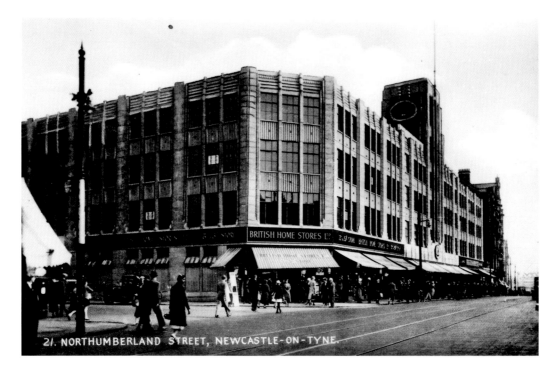

This rather large building housed branches of British Home Stores and C&A. It was largely demolished in the 1970s although the section furthest from the camera still survives and today is the home of Next. The former C&A section is now occupied by Primark, who installed the large glass window above the street.

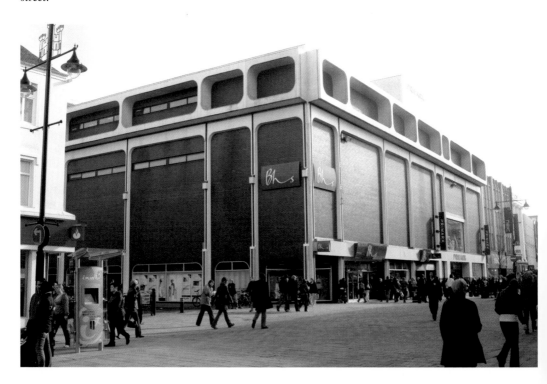

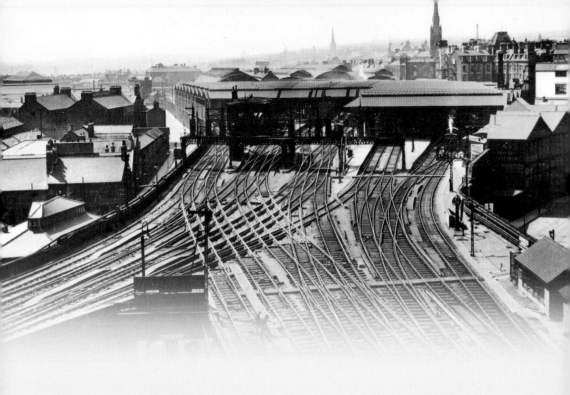

chapter 3

The Central Station

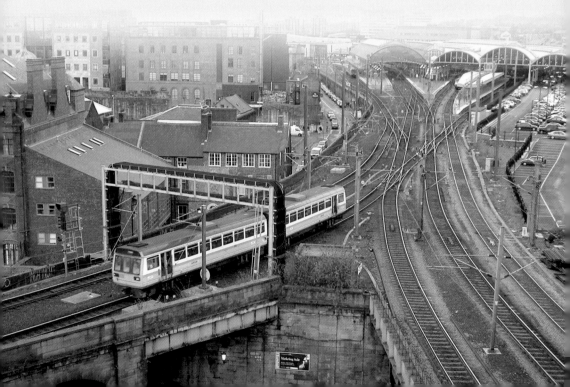

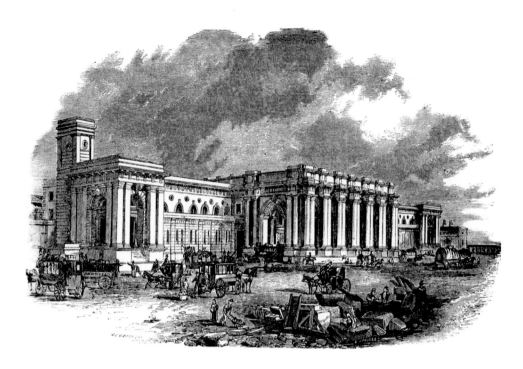

This design for Central Station, *c.*1849-1850, was never executed. The structure we see today was scaled down from the original design for reasons of economy, but it is still very impressive. At the time of the station's official opening on 29 August by Queen Victoria, this portico was not complete. Below, a plan of the station in 1859. The lines on the left were those of the Newcastle and Carlisle Railway, the platforms at the upper right were used by the Newcastle and Berwick and those at the bottom right were served by trains crossing the Tyne by the High Level Bridge.

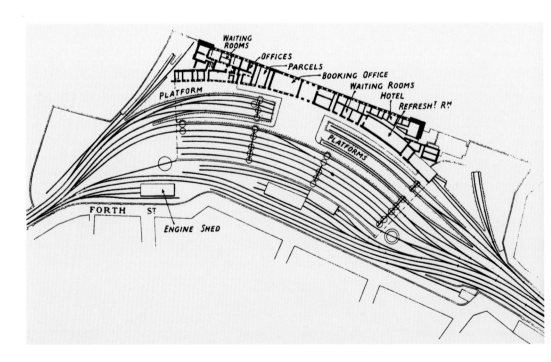

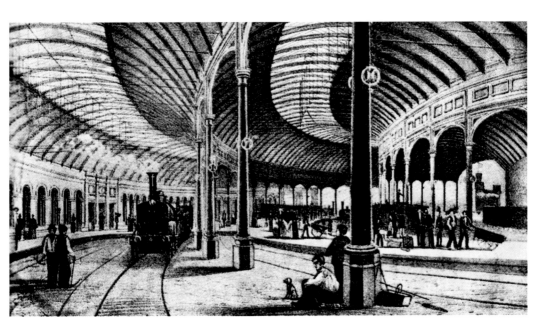

The interior of Central Station *c.*1850. In 1866 the rails were lowered 21 inches to increase the platform height – just one of a series of changes over the years. Below, an illustration from the 10 August 1850 issue of *London Illustrated News* which carried coverage of a public dinner held for Robert Stephenson in a specially sectioned off part of the station. This area is likely to be very close to where the current travel centre is now. The ILN commented, 'No other site in the town could more fittingly have been appropriated for the purpose. Three beautiful cartoons of gigantic dimensions adorned one side of the dining room, representing three of the great works planned and executed by Mr Stephenson, The High Level Bridge, the tubular bridge across the Menai and the Berwick Bridge. These paintings, although hastily executed for the occasion, do great credit to the artists Mr John Story, Mr John Gillson and Mr R.S. Scott.'

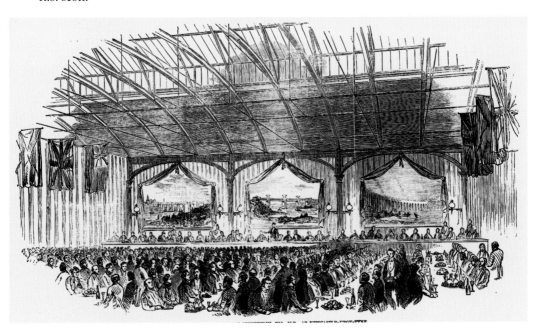

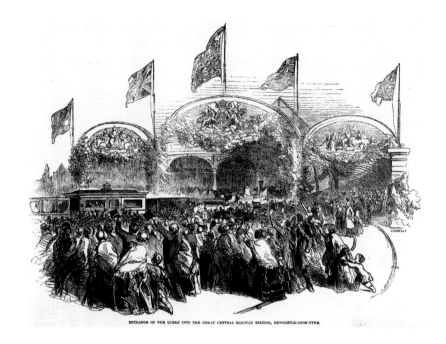

ENTRANCE OF THE QUEEN INTO THE GREAT CENTRAL RAILWAY STATION, NEWCASTLE-UPON-TYNE.

The royal train arriving at Newcastle for the official opening of the station as appeared in the 7 September 1850 issue of *London Illustrated News*. The paper commented that 'the entire available space within this splendid shedding was occupied by the inhabitants of Newcastle. The entrance to the station was handsomely decorated with evergreens; and above each archway were erected emblematical bass reliefs. Outside the station and along the line of the railway an immense concourse of spectators had been assembled, and every corner was highly respectable assemblage. As the hour approached for the arrival of the train, the excitement rose to fever heat. As at last it came in sight and slowly drifted in amidst defining cheers and the waving of a perfect sea of handkerchiefs and hats.'

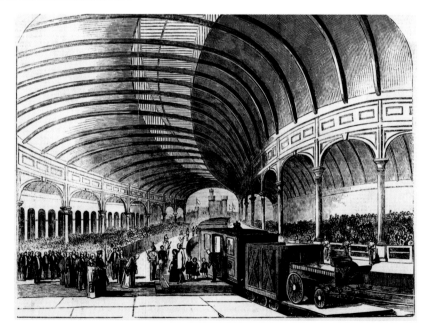

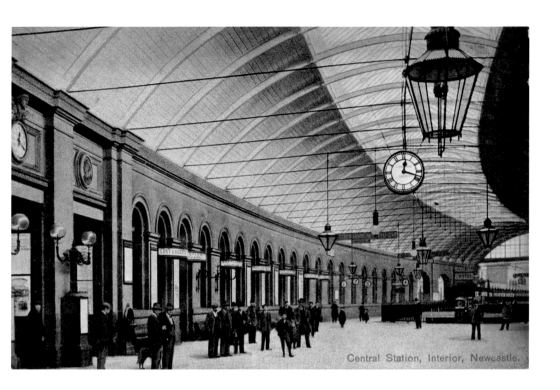

Central Station, Interior, Newcastle.

The Central Station interior *c*.1900 and around 100 years later in 2009.

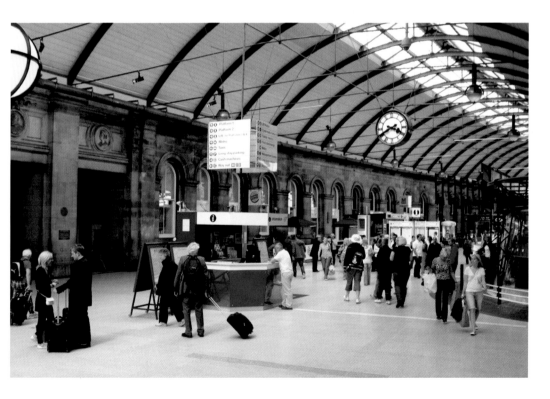

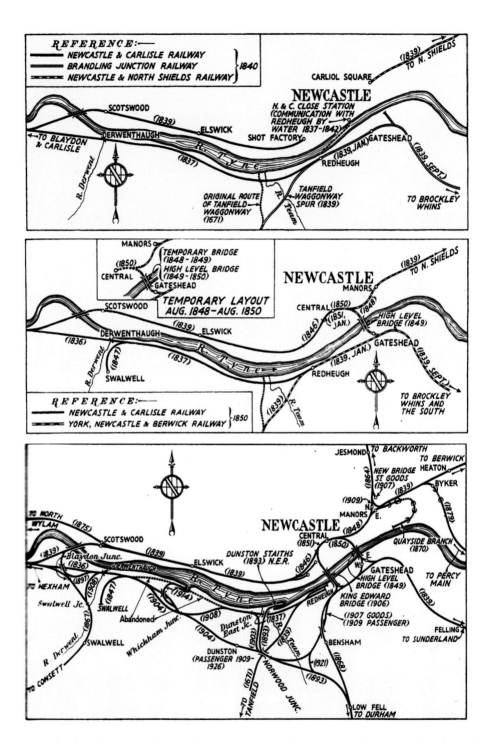

Principal railway lines around Newcastle c.1840, 1850 and 1937. In 1840 the Newcastle and North Shields railway terminated at Carliol square. By 1850 the Central Station and High Level Bridge were in place, however, north-south trains had to run into Central Station and reverse out. By 1937 the King Edward Bridge had long been in place allowing trains to run directly from the south to Scotland. The High Level and King Edward bridges form a circular route still in place today.

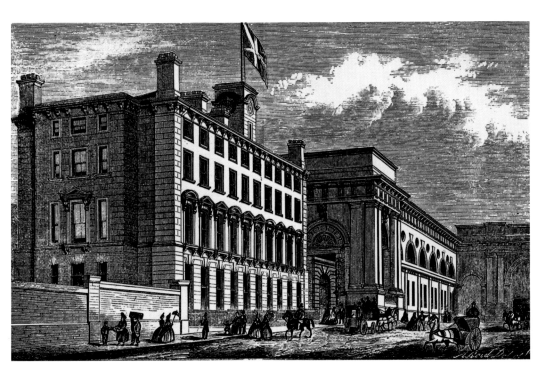

The Royal Station Hotel. Today's structure is actually a combination of the one built by the North Eastern railway in 1863; see above, with a much bigger extension built in 1892. The combined block is seen below. The extension also involved building an extra two floors on top of the 1863 structure. Today the hotel now features 144 spacious ensuite bedrooms, ten conference suites and wireless high speed internet in all areas.

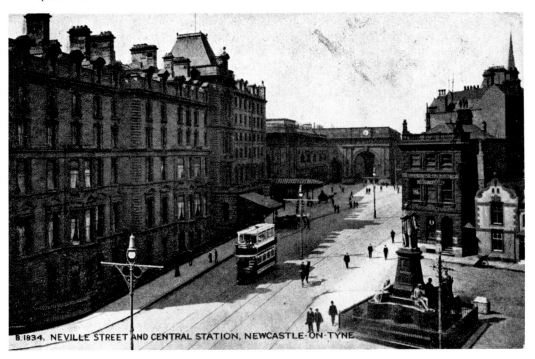

B.1834. NEVILLE STREET AND CENTRAL STATION, NEWCASTLE-ON-TYNE.

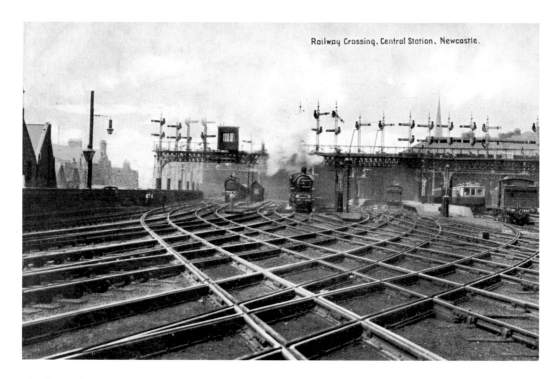

The diamond crossing at the east of Central Station, along with its accompanying signal box and gantry was one of the most distinctive features of the station layout. The platforms to the right were known as Tynemouth Square which was the terminus of the North Tyneside commuter services. In the above image one of the North Eastern Railways electric trains is visible.

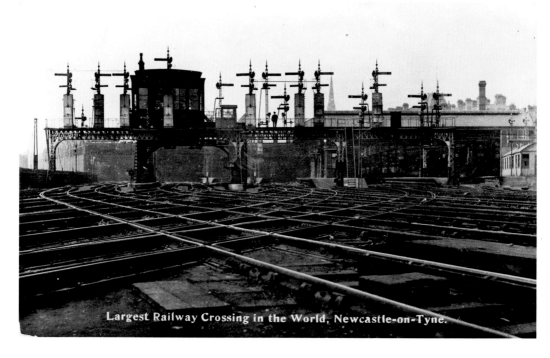

Largest Railway Crossing in the World, Newcastle-on-Tyne.

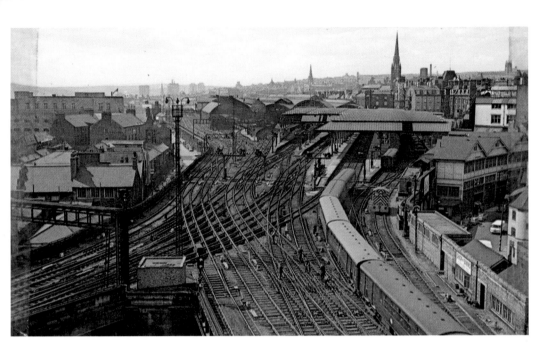

The diamond crossing seen from Castle Keep is on one of the classic railway views of Newcastle and has been captured by many a railway photographer. The above image shows it probably around the height of its use in the late 1950s. Some electric suburban stock is seen just outside the platforms of Tynemouth Square. The non-mainline services were cut back greatly in the 1960s and then decreased further as the metro put the Tyneside suburban lines in tunnels under the heart of Newcastle. Below, the same view around 2003. When the station was opened this junction was a relatively simple affair as the station's services were separated into those coming in from the south and those from the north. The junction was rationalised in the electrification of the East Coast Main Line in the 1980s.

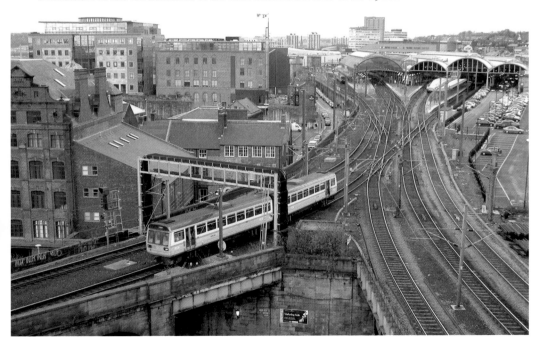

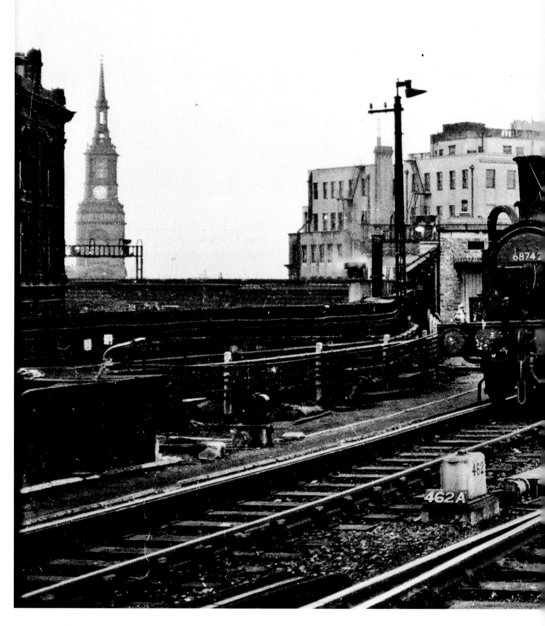

An ex-North Eastern Railway station pilot J72 class 68742 on the diamond crossing. Sister loco 68743 was also a station pilot. Alongside is a Diesel Multiple unit, one of many running on British railways at the time.

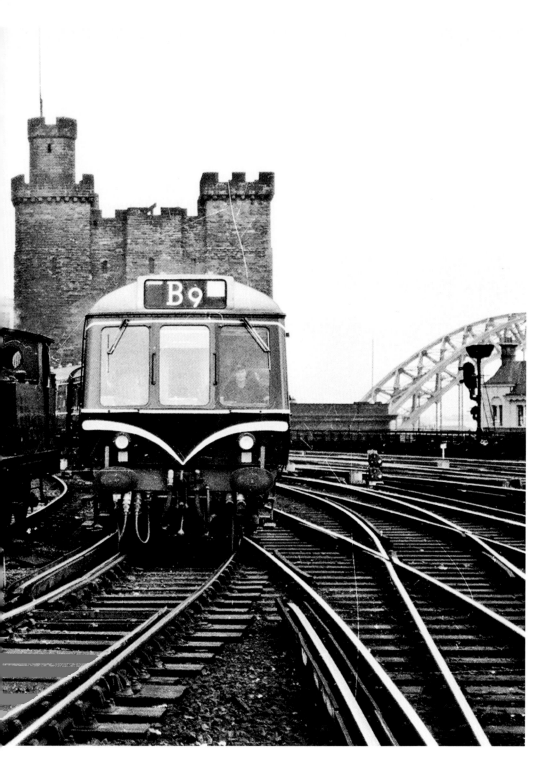

The DMU body profile makes it looks like a high-density class 115 (built by BR Derby) 117 (built by Pressed Steel of Glasgow). This type seems to have been tried briefly in the Newcastle area.

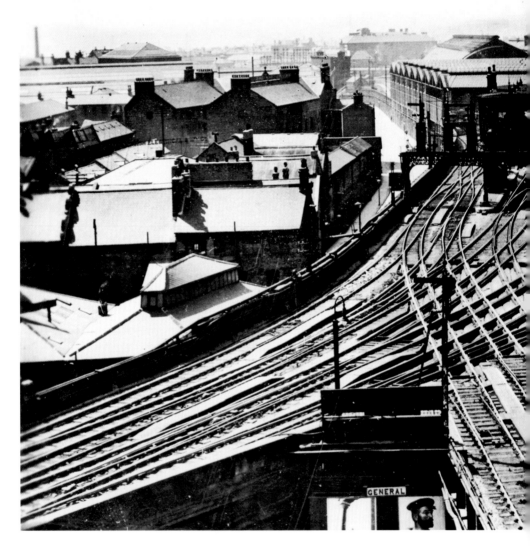

GENERAL

A classic postcard view of the station and the diamond crossing. An 1889 town guide describes the station as 'one of the most elegant and commodious in the Kingdom. It is of great advantage to the town to have all the railway termini with on small exception centred in one spot. The building is of polished stone, and was planned by the late Mr Dobson. In the choice of a style the architect has followed the example of the ancient Romans. It was intended that the portico should run along the whole front. Unfortunately a depression in railway property took place before the station was finished and this part of the design was suppressed. A portico on a comparatively limited scale, and shorn of some of the artistic embellishments of the original design was subsequently reared.' After the official opening of the station

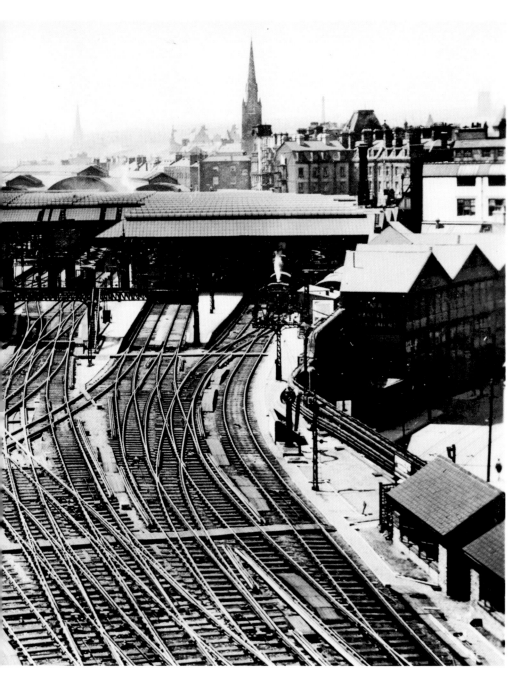

in 1850 the royal train would have run up the line to the right of the picture. The *London Illustrated News* commented: 'The royal train left Newcastle at a quarter past one. From every point from which a glimpse, however passing, of the illustrious visitors was crowded with occupants. The north end of the High Level Bridge was crowded with occupants. The Interstices of the spire of St Nicholas's church had their occupants. The windows, down to the smallest pigeon hole that ever lighted a garret had women and children's heads thrust through them. Nearly every house top was occupied. On open spaces and street corners placed lower than the line a sea of upturned faces presented themselves.'

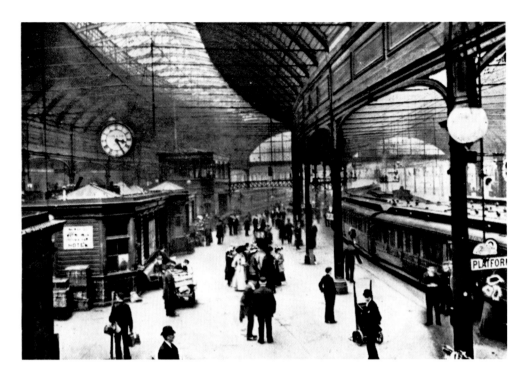

Postcard views showing what is now Platform 2. The Central Station has had a number of owners/operators over the years. It was built for the York, Newcastle and Berwick Railway Company, which became the North Eastern Railway, NER, in 1854, and the Newcastle and Carlisle Railway, which was later absorbed by NER in 1862. In 1923 it was grouped into the London and North Eastern railway that made many alterations and improvements to the station. Indeed much of the LNER 'look' survived until around 1990. The station came into the ownership of British Railways on 1st January 1948. The station was upgraded during late 1980s East Coast Main Line electrification programme.

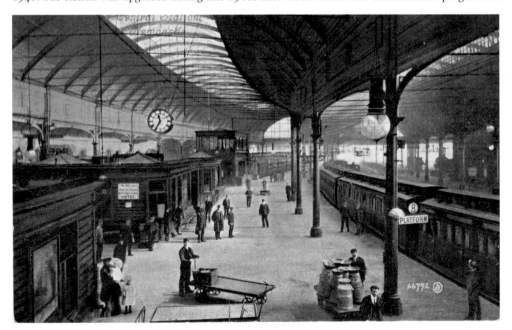

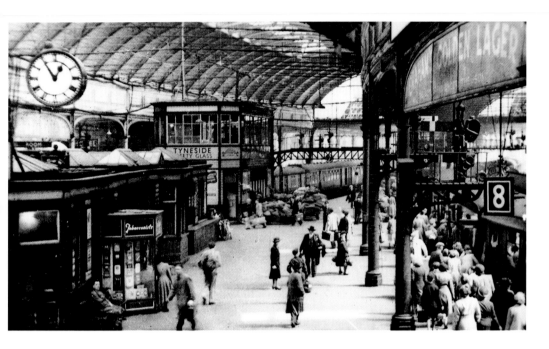

The alterations actually moved its appearance slightly closer to its original look. From 1996, during the rail privatisation process, Great North Eastern Railways became the station operator and the structure was largely painted out in their colours. Financial difficulties meant their franchise was taken over in 2007 by National Express East Coast. NXEC have since encountered their own financial difficulties and in May 2009 their franchise was suspended and replaced with a management contract until it can be re-let.

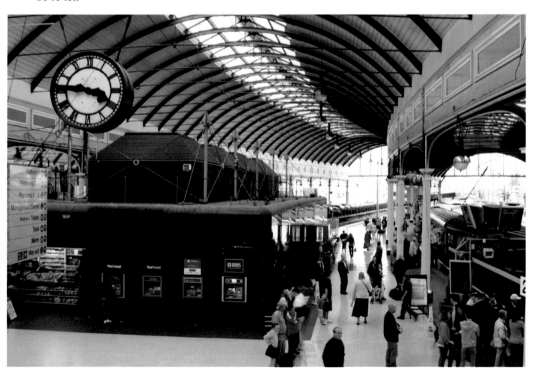

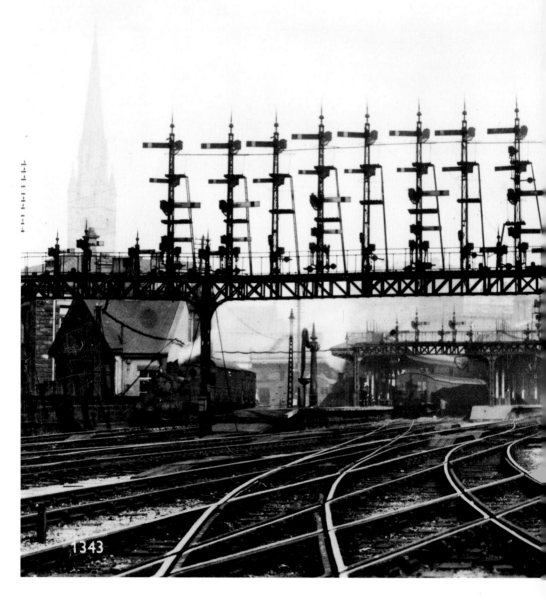

The Central Station from the west.

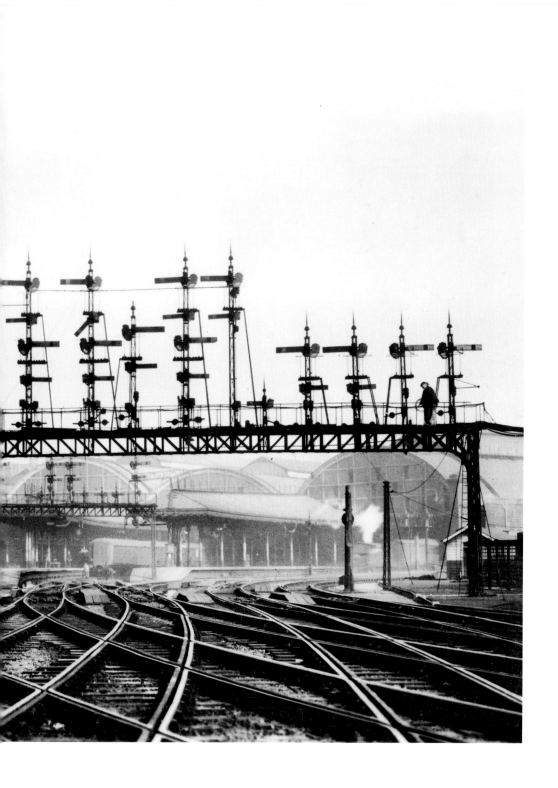

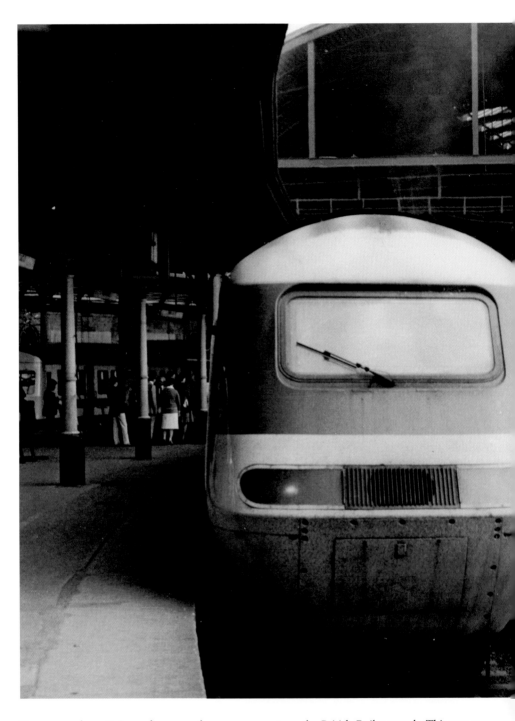

From around 1976 signs of progress became apparent on the British Rail network. This was a network still contracting after the Beaching cuts and at a time when the railways were seen by many as a poor relation of the rapidly spreading motorways. The Intercity 125 train had arrived, and is actually a branding rather than a locomotive type. The roots of the HST stretch back to the late 1960s. A prototype train was completed in August 1972. By 1976 and by 1978 the new trains were running in regular service on mainline service including the East Coast Main Line to Newcastle.

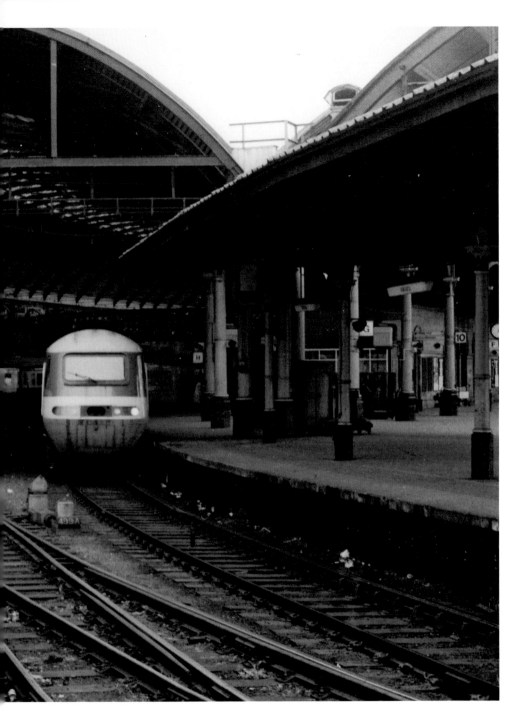

The new trains caught the imagination of the public and were often seen on TV advertisements fronted by Jimmy Savile and plugged with the strap-line 'This Is The Age Of The Train'. Two of the locomotives are pictured above at Newcastle. This class are now often regarded as the most successful diesel locomotives ever built. Many were displaced from the East Coast Main Line by electrification and the arrival of the intercity 225 train but around sixteen still remain providing services to destinations north of Edinburgh beyond the electrified lines.

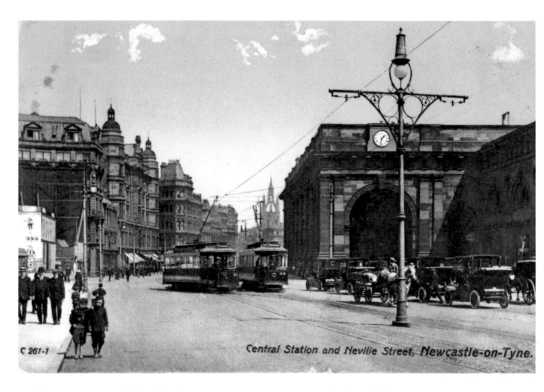

Central Station and Neville Street, Newcastle-on-Tyne.

Neville Street, presumably early afternoon. It's interesting to see shoeless children on the opposite side of the street to the motor cars. This may be a composite image, as postcard companies were seldom above doctoring them to increase their saleability. Below, a similar view but from a later period, and this time far more indebted to the artist's brush.

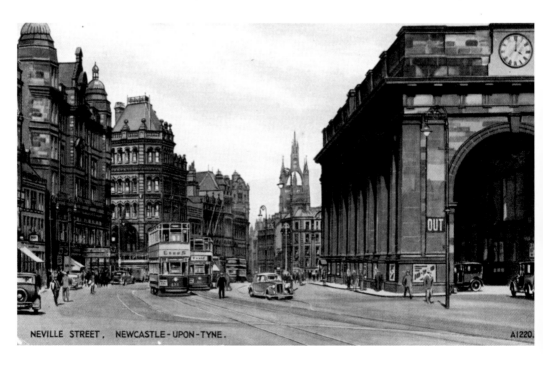

NEVILLE STREET, NEWCASTLE-UPON-TYNE. A1220.

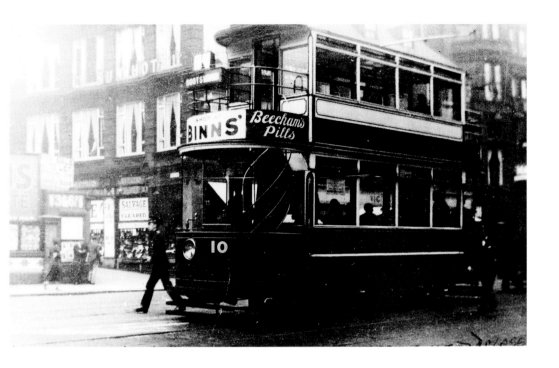

Newcastle tramcar No. 10. Built in 1906, it may have incorporated equipment from the original No. 10 – a single-deck car. The very varied fleet at one time reached more than 300, with several distinctive types of single and double-deck two and four-axle cars and, briefly, two experimental three-axle cars. A front exit and rear entrance on most Newcastle trams aided rapid loading and unloading.

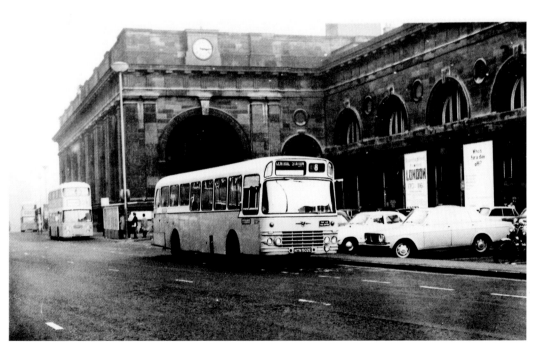

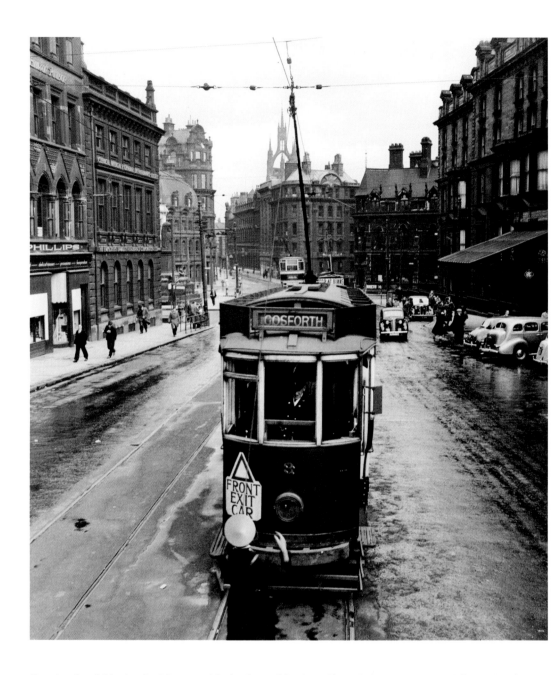

Gateshead and District Car No. 3 outside the Central Station. (Photo D.W.K. Jones, copyright National Tramway Museum.) The last tram (so far) to run through the streets of Newcastle departed from this point on the evening of 4 August 1951. Tramway historian George Hearse writes that 'A large crowd was waiting at the Newcastle Central Station to give a loud send off to then last service car No. 20. It left at 11pm driven by motorman William Aiston and conducted by former motorman George Timmins. Apart from the usual collection of 'drunks' who frequented late night cars there were many making the last journey for sentimental reasons.' George Hearse then adds that following this came car No. 16, carrying a group of Gateshead and Newcastle council dignitaries as well as officials from the British Electric Traction Company and the Gateshead and District Omnibus Company, who had been entertained to dinner at the Royal Station Hotel.

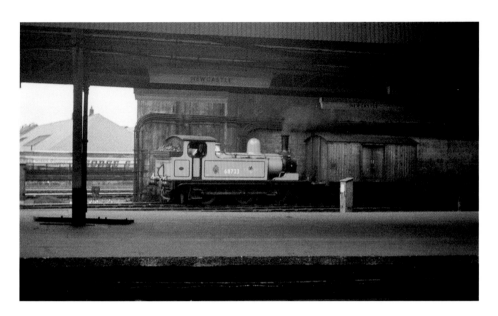

Shunting locomotives at Central Station. Above, J72 0-6-0T, Newcastle station pilot 68723, blue in BR days, but in NER green. This area of the station was rebuilt during the electrification of the late 1980s early 1990s and it appears to be standing where Platform 5 is now. Below, class 03 0-6-0 diesel shunter 03063, coupled to its match wagon. These wagons enabled short-wheelbase locomotives like class 03s to operate track circuits. These locos were also used as station pilots at Newcastle until the late 1980s. A class 47 loco is stabled behind. Both are in BR blue. Many of these diesel locomotives were direct replacements for steam shunting engines in the 1950s modernisation programmes. However, by the 1970s there had been a significant decline in the need for shunting engines as mixed goods trains gave way to point-to-point deliveries and many such locomotives found themselves to be redundant.

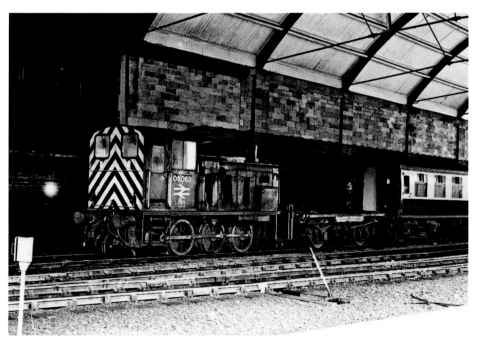

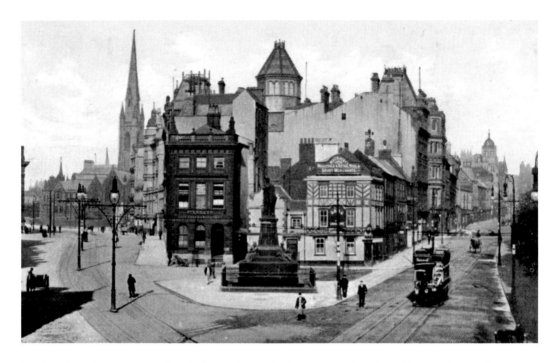

The junction of Westgate Road and Neville Street. The images reproduced on this spread range from about 1906 to 2009. The monument to George Stephenson can be seen in the centre of the images. Curiously he is looking away from Central Station.

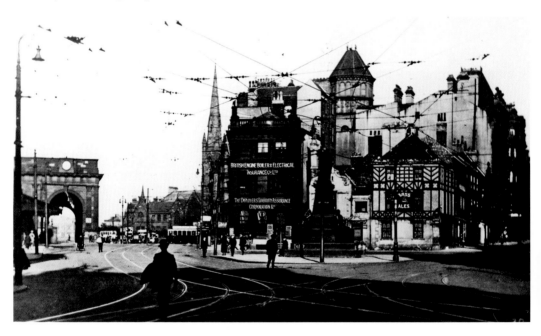

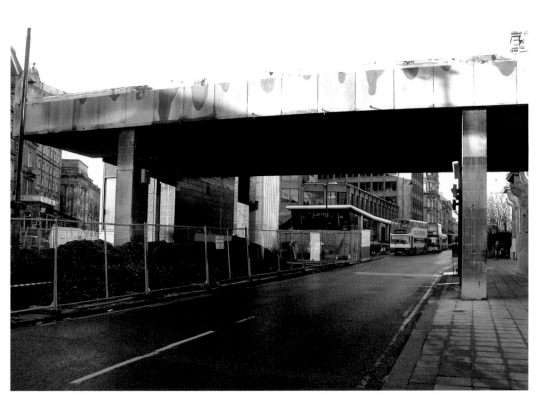

Above, for many years the view was blocked by a large office block straddling the road junction. The image shows it in its last stages of demolition. Below, the buildings to the center of this series of images have been redeveloped and part of the site is now occupied by The Long Bar.

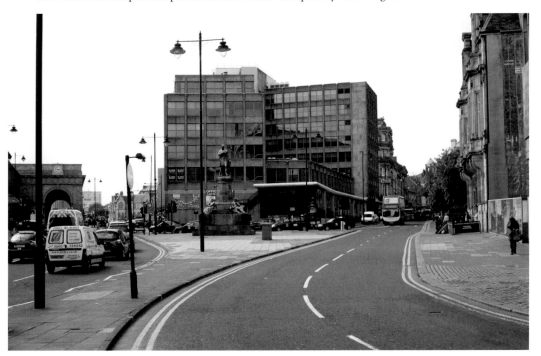

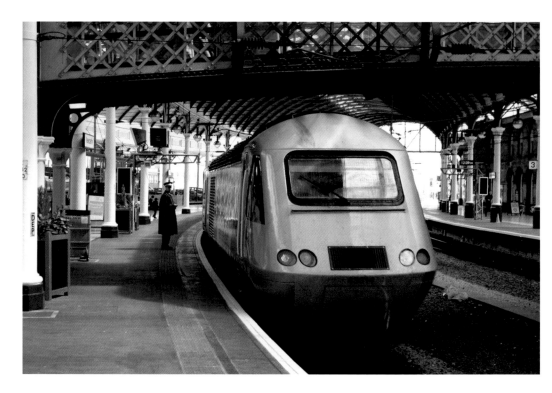

An intercity 125 train in National Express East Coast colours running through Platform on 25 April 2009. These trains gained an extra coach in 2002 in response to increasing passenger traffic. From 2007 GNER began a programme of refurbishment to the train interiors and also began replacement of the locomotive power units.

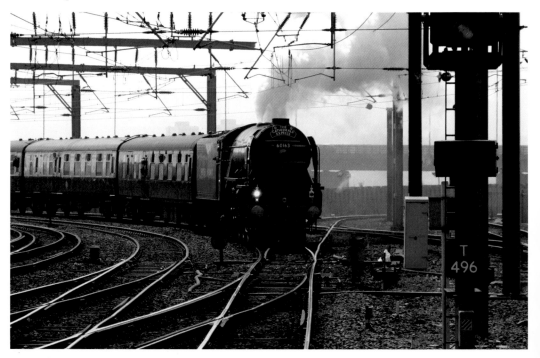

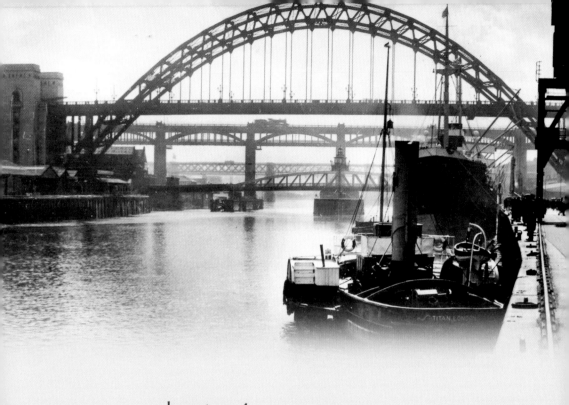

chapter 4

Bridges

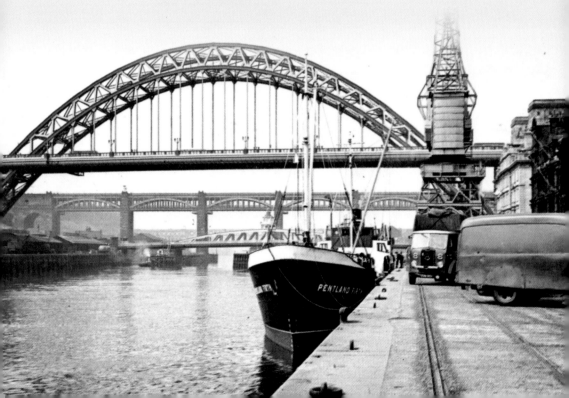

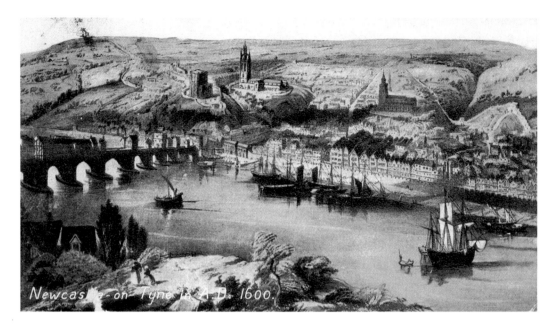

Newcastle-on-Tyne in A.D. 1600.

An old joke goes 'Which place in the UK has exactly the same number of bridges as Newcastle?' Don't know? Think about it. Well, the answer is Gateshead. At the risk of raising ire from the Gateshead folks, Newcastle has always been more identified with the Tyne bridges than its southern neighbour, but that is a story for another book. The image above shows the bridge which was swept away in the flood of 1771. Below, the High Level Bridge is in position. In front is the stone bridge which was begun in 1774 and completed in 1779, then widened and enlarged in 1801. A blue stone across the pavement about two thirds from the Newcastle side defined the Newcastle/Gateshead jurisdiction boundary. For some time a Newcastle thief could not be pursued beyond the blue stone by a Newcastle policemen.

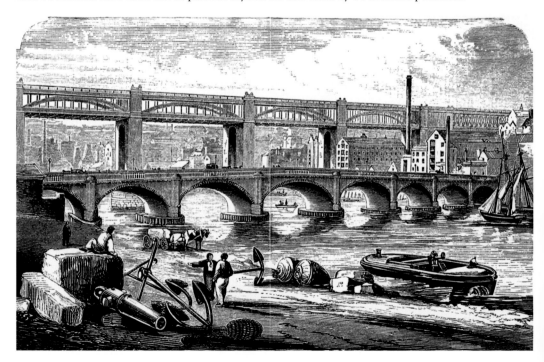

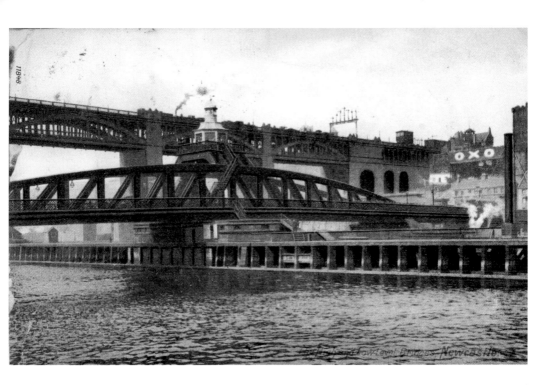

A postcard image of the same area with the swing bridge in place. Since its inauguration in 1876 and 1981, the bridge has been opened 286,281 times allowing 448,090 vessels of around in total 220 million net tonnes to pass through. The image below is taken from the grounds of the Sage Music Centre in Gateshead and shows the view today with perhaps the most iconic bridge in Newcastle the Tyne, which was completed in 1928.

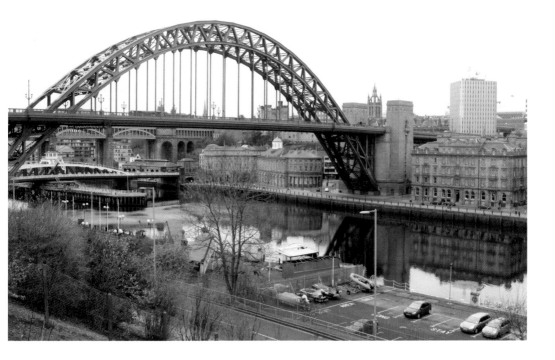

A Newcastle Corporation bus runs under the East Coast Main Line on the approach to the High Level Bridge. Newcastle Corporation used to operate several bus services into Gateshead. This was basically a continuation of the through running agreements that developed between the Newcastle and Gateshead tram networks. Below, the Newcastle-side approach to the bridge.

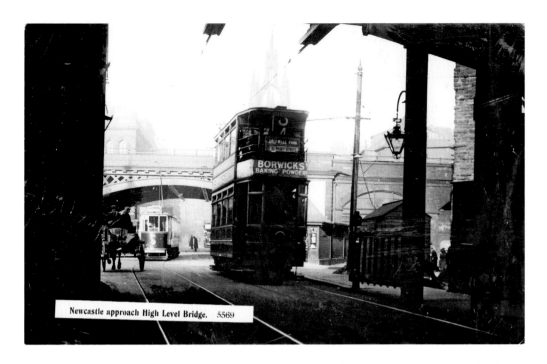

Newcastle approach High Level Bridge. 5569

A tram about to cross the High Level Bridge. Trams run on rails allowing them to pass each other at high speed in confined spaces with ease. However, with buses it was more difficult. Anecdotally, advice to drivers on passing the bridge was 'drive on, just look straight ahead, and don't even think about a crash'. The pending reopening of the bridge offered the chance of a bus only route across the Tyne and route services off the Tyne Bridge. Unfortunately, on reopening the bridge could only be used by southbound bus and taxi traffic.

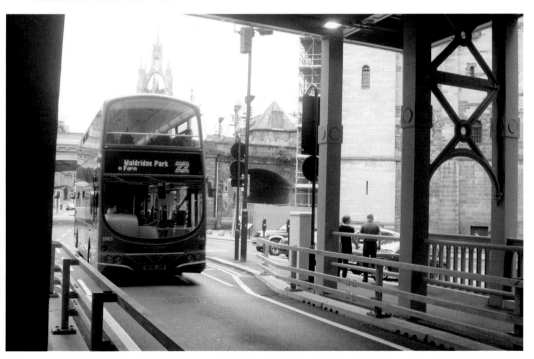

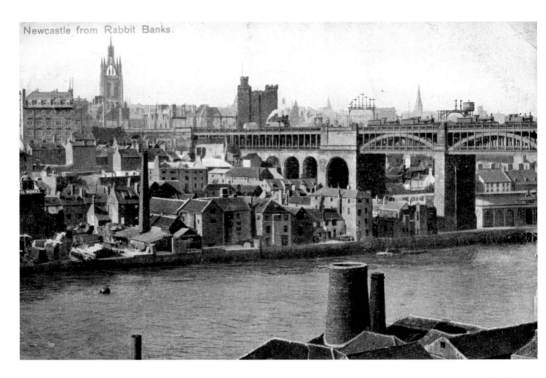

A simple comparison of part of Newcastle quayside and the High Level Bridge. Due to the growth of trees on the Gateshead side it was impossible to take the modern photograph from exactly the same viewpoint. Had post-war plans to build a new Tyne Road crossing alongside the High Level Bridge to the west come to fruition, this view might have looked very different. Interestingly, the locomotive on the bridge appears to be running 'light'.

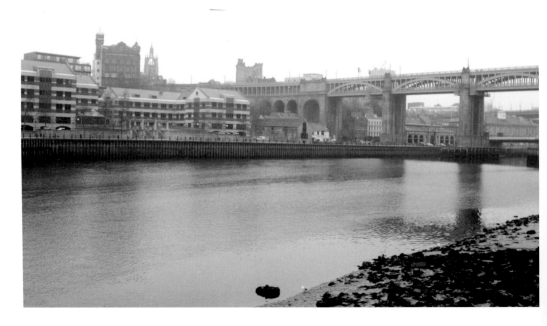

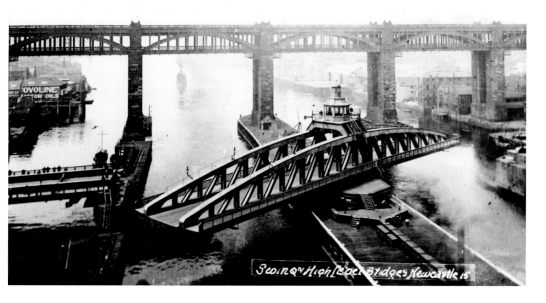

The swing bridge was designed and built by Sir W.G. Armstrong & Co, under Tyne Improvement Commission supervision. Work began in 1873 and was completed in 1876. It was apparently opened for road traffic on 15 June 1876 without ceremony. It was opened for river traffic on 17 July 1876. An 1889 guide commented that 'The swing bridge at Newcastle has three masonry piers, built upon cast iron cylinders sunk to the rock at a depth of 45 feet below low water, and filled with cement concrete. The bridge has four openings for navigation, two of which, 104 feet each in clear width, are spanned by the girders of that portion of the iron superstructure which swings round on the central pier. The width of the bridge is 48 feet, divided into a centre passage-way for vehicles, and a footway on each side. The total length of the bridge is 560 feet. The portion which swings round is 281 feet long, and weighs 1450 tons. The superstructure is moved by means of water power – in fact the whole of the movable portion is seated upon a hydraulic ram, which firstly sustains it until it has been brought round, when it is again allowed to settle down on its bearings so that it swings round on a cushion of water.'

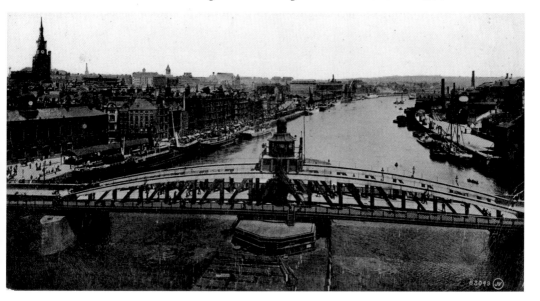

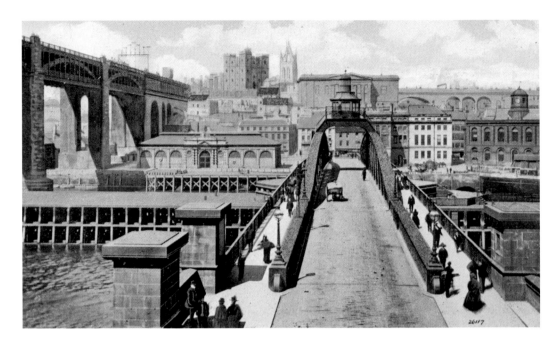

Traffic levels today seem little different in these two views of the swing bridge, which must be around 100 years apart. It has been a Tyne crossing since at least AD 120 when the emperor Aelius Hadrianus built a bridge on or near this site and established a military station on the north bank of the river. Then, on the morning of Sunday 17 November 1771 flooding largely swept away the medieval bridge with the loss of six lives and much property. Today the swing bridge continues to provide a useful link at river level. The swing bridge has replaced the stone bridge which was demolished on 23 September 1868 to allow larger ships to move upriver to Armstrong's works. In removing the stone bridge foundations, portions of the two former bridges – one medieval and one Roman – were discovered. Below, the scene today with the Tyne Bridge in the closed position.

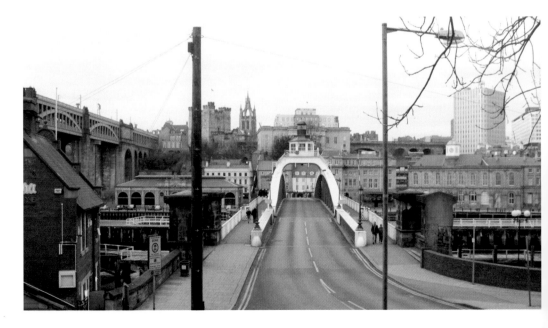

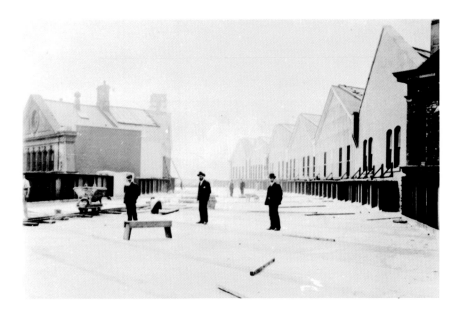

In order to take the pressure off rail traffic on the High Level Bridge, the North Eastern Railway began construction on a second rail crossing, the King Edward Bridge, in 1902. Somewhat embarrassingly for the company, the preferred route involved slicing through part of the recently completed Forth Banks goods shed (as can be seen above). Below, the bridge under construction. The bridge was designed and engineered by Charles A. Harrison, the chief civil engineer of the North Eastern Railway, and it was built by the Cleveland Bridge & Engineering Company in Darlington, 1902-1906. The bridge is rather inelegant but it is functional and consists of four lattice steel spans resting on concrete piers. Its total length is 1,150 ft (350 m) and 112 ft (34 m) above high water mark. The bridge was opened by King Edward VII and Queen Alexandra on 10 July 1906. The total cost amounted to £500,000.

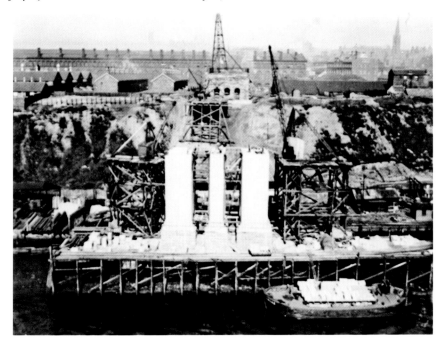

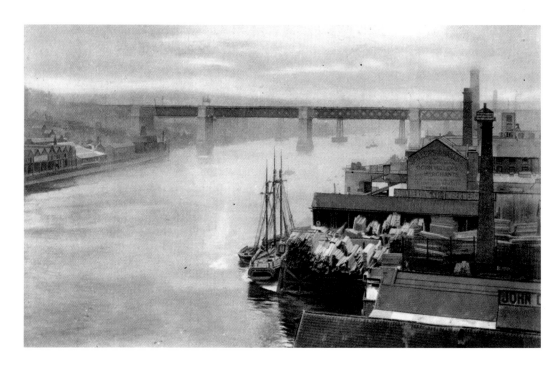

Above, The King Edward VII Bridge, apparently from the Newcastle side looking west. Below, looking from the Gateshead side towards the east. The railway running below the bridge was used as a route linking Carlisle to Tyneside. With the opening on Newcastle Central Station, passenger services were then diverted to Newcastle via the north bank. These tracks remained in place for many years and some of their associated structures still remain today.

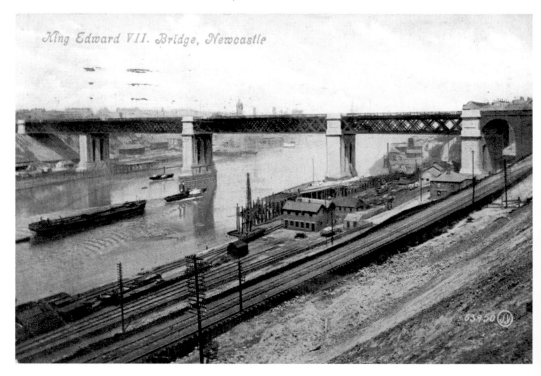

King Edward VII. Bridge, Newcastle

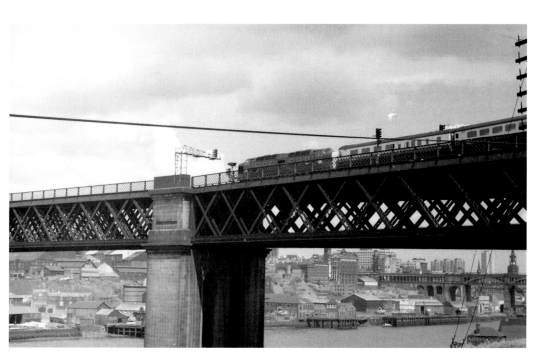

The King Edward VII Bridge in the early 1970s. Note the absence of the metro bridge. The Newcastle of this time would still have been associated with the movie *Get Carter*. In a few years the dereliction of industry would start giving way to the consumerism of the 1980s. Now landscaped and laid out with a footpath the area below the bridge can be used today for leisure pursuits. It is, however, still a rather lonely, and even slightly eerie, spot in the middle of the urban hubbub. Much of the former rail route is now used as a bus only link between Gateshead Metro Station and the Metrocentre.

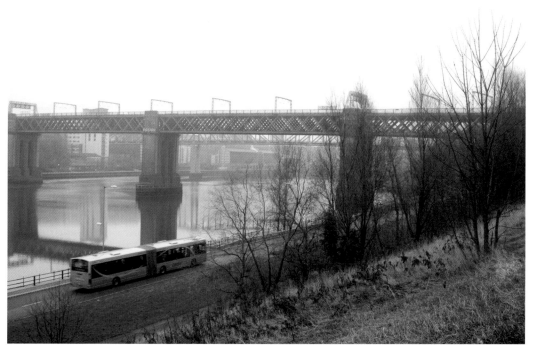

A series of views of the Newcastle approach to the Tyne Bridge. The first shows the rather interesting bridge which carried the East Coast Main Line over the bridge approach road. Just visible behind the bridge is the former Royal Arcade, demolished in 1964. A plaster replica of the interior can be found in the Swann House building. The later pictures also capture an example of the rise of the office block in Newcastle and their subsequent refurbishment.

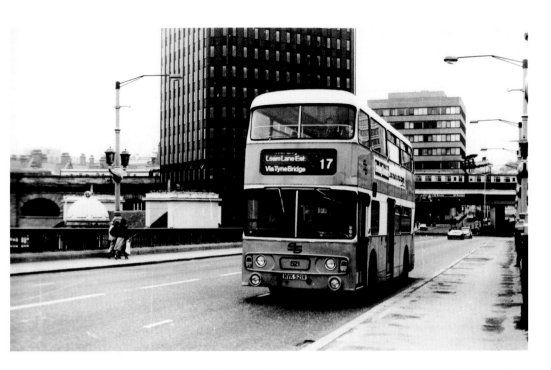

Above is a yellow PTE bus crossing the Tyne Bridge on its way to the Leam Lane Estate. Apparently on the official opening day, as the procession was getting ready to cross the bridge, a big yellow mongrel dog suddenly galloped down the deserted road between the waiting hosts. Then several bus loads of policemen rattled by as if in pursuit. According to the local press it was too much for the Tyneside sense of the ridiculous and a roar of laughter burst out all along the road. Below, the same scene a couple of decades later.

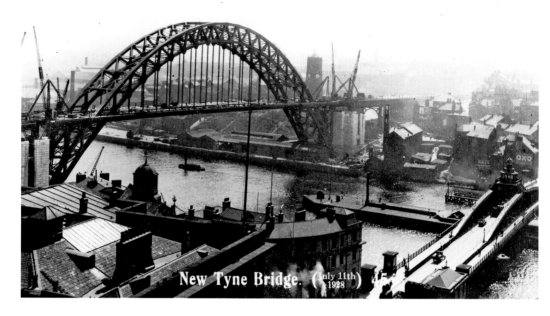

New Tyne Bridge. (July 11th 1928)

The iconic Tyne Bridge during construction and after completion. Although opened by royalty, on 10 October King George V and Queen Mary performed the duty and were the first to use the roadway travelling in their Ascot landau, the bridge was arguably a symbol of the age of the common man. It was toll free, partially funded by central government and although used by trams represented the growing power and importance of the roads and the internal combustion engine. The Tyne Bridge was designed by Mott, Hay and Anderson and based the design for the Hell Gate Bridge in New York and the Sydney Harbour Bridge.

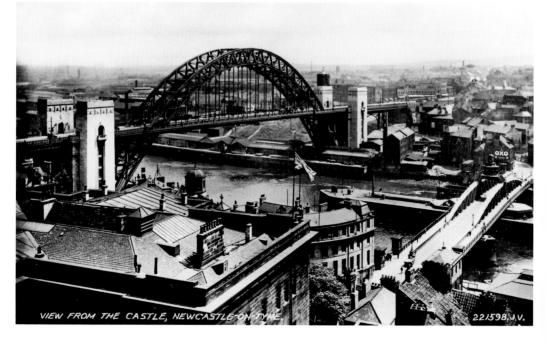

VIEW FROM THE CASTLE, NEWCASTLE-ON-TYNE. 22.1598.J.V.

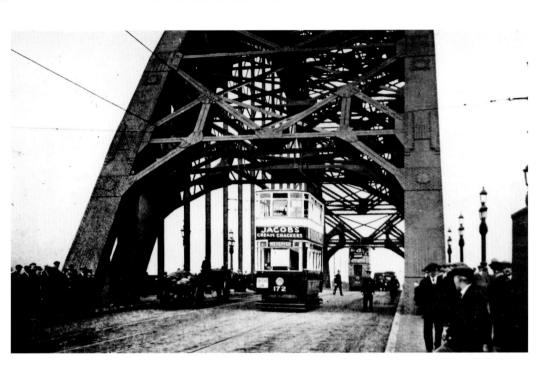

A tram crossing the Tyne Bridge.
Trams were being seen as things of the
past when the Tyne Bridge was under
construction. There was opposition
to them being included by the Royal
Automobile Club on the grounds that
they would slow traffic across the new
bridge. However, routing them across the
bridge would have an immediate financial
advantage for Newcastle Council. In the
twenties the tram services of Newcastle
and Gateshead could account for around
two million passenger journeys a week,
and tolls were payable to the railway
company for each car that crossed the
High Level Bridge. The laying of tram
track across the new bridge allowed the
diversion of many services away from the
High Level Bridge at a projected saving
of around £15 000 a year. This line was
to be the last tramway extension on
Tyneside and survived until the end of the
final tram service on Tyneside in 1951.
Left, an anonymous personal photograph
taken on the bridge, that came into the
author's possession at a local antiques
fair.

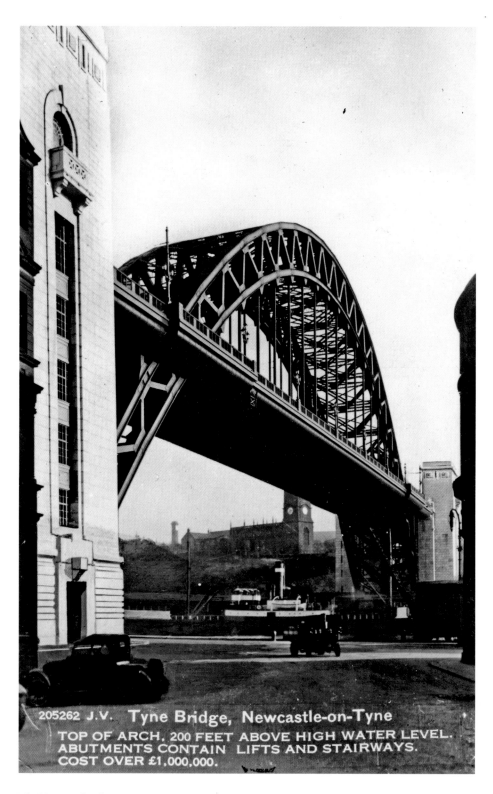

205262 J.V. **Tyne Bridge, Newcastle-on-Tyne**
TOP OF ARCH, 200 FEET ABOVE HIGH WATER LEVEL.
ABUTMENTS CONTAIN LIFTS AND STAIRWAYS.
COST OVER £1,000,000.

The Tyne Bridge from Dean Street.

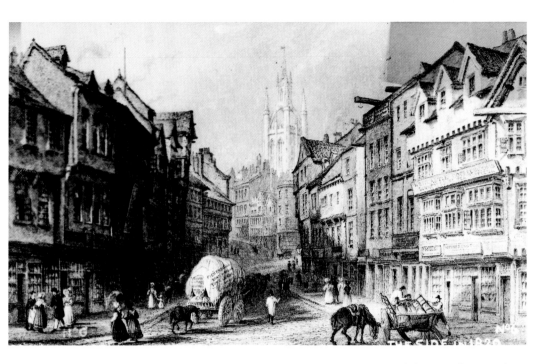

The process of putting together this book has opened my eyes to many of the city's features that I have previously walked, or staggered, past without noticing. Dean Street Viaduct is an example. This impressive structure was built by Rush and Lawton and opened for traffic on 29th August 1848. The viaduct was widened in 1893 to allow the number of rail tracks to be increased from two to four. Part of an arch on the east side of the viaduct has been incorporated into a restaurant. The views show the area of the bridge from the north before and after completion and a view from the top of the Castle Keep in May, 1964.

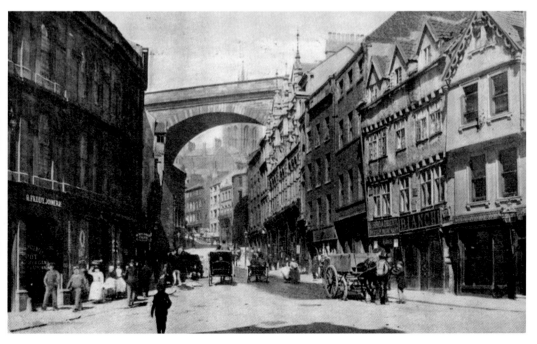

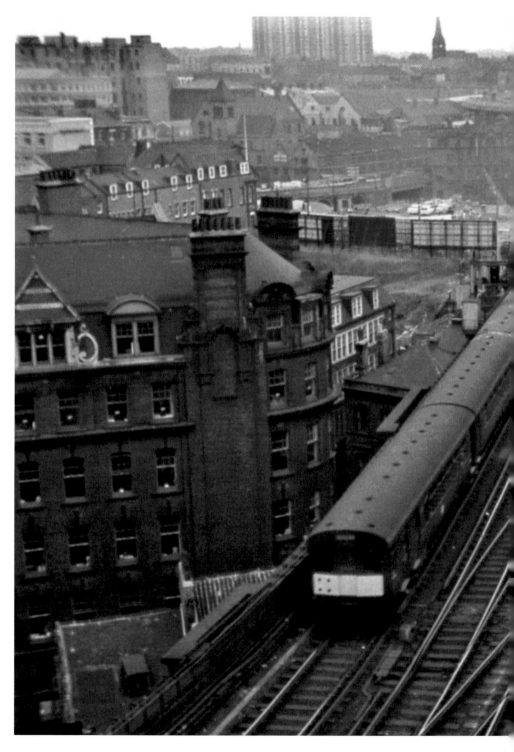

Dean Street bridge from Castle Keep. A Tyneside electric multiple unit, often just referred to as the Tyneside electrics, and an A3 class Pacific locomotive are also visible (picture courtesy Ron Fisher).

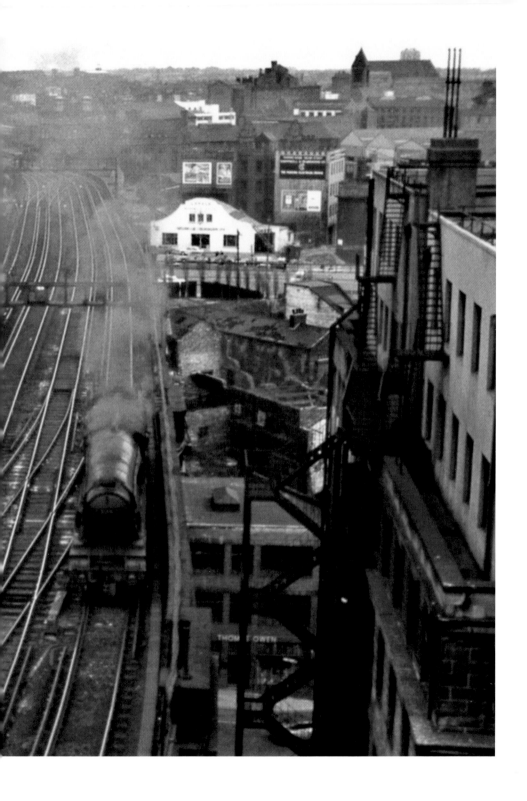

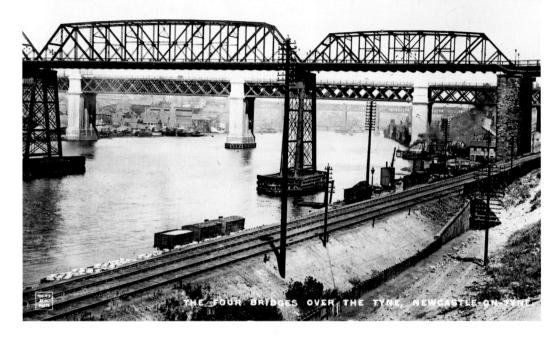

Postcard images of the second Redheugh Bridge. Construction began in 1897 with the new bridge being built around the structure of the previous 1868 bridge. By the 1960s, serious flaws in the design of the new bridge led to speed and weight restrictions being imposed. The decision was then taken to build the present Redheugh bridge which opened on 18 May 1983. The old structure remained for some time and could be used as a pedestrian crossing, but was demolished in late 1984.

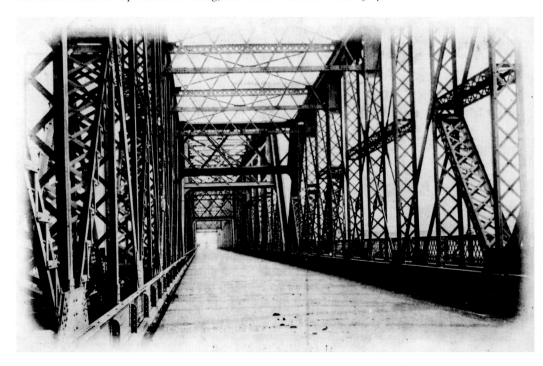

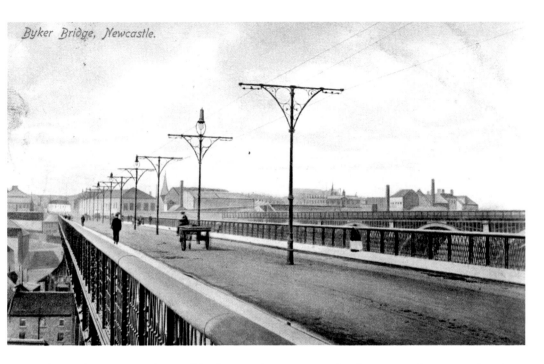

Byker Bridge, Newcastle.

Byker Bridge was opened as a toll bridge to pedestrians on 19 October 1878 and to carts and carriages on 27 January 1879. The half penny toll was withdrawn on 12 April 1895. Originally 30 ft wide the bridge was extended to 50 ft in 1899. The above image is some time after that as the tram track is in place. The deck of the bridge was rebuilt between May 1985 and March 1986. Below, the bridge from the metro viaduct (photograph courtesy of Tony Walmsley).

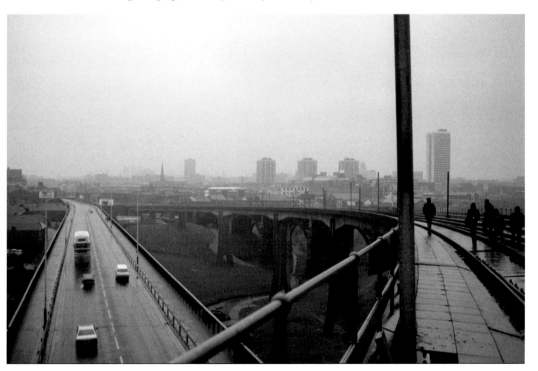

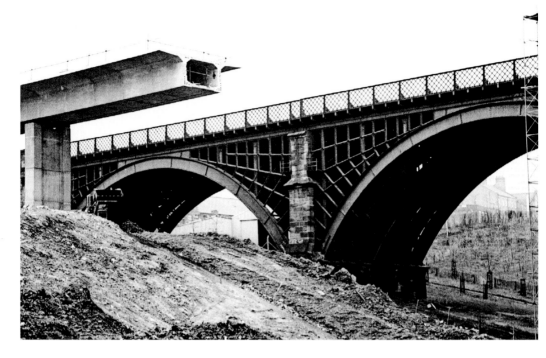

Byker Metro viaduct under construction. Work on the 18 span 820 metre long viaduct began in 1977. Building it between two existing viaducts, the presence of old mine workings and weak overlying ground added to complications in construction. It was completed July 1979. Passenger carrying began on 11 November 1982 with the opening of the St James to Tynemouth metro line. Below, Byker Bridge again seen from the metro viaduct (photograph from Tony Walmsley).

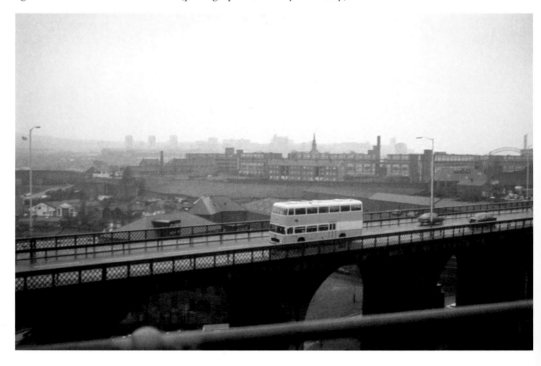

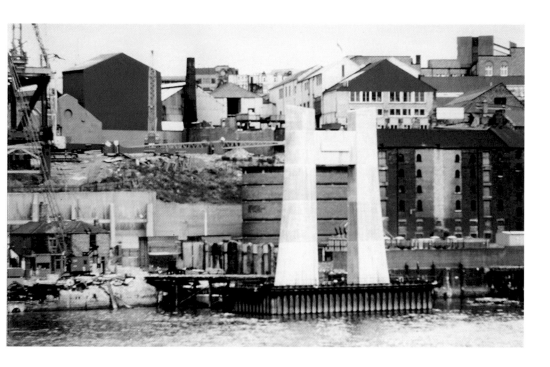

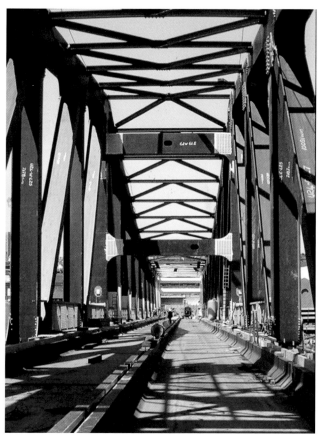

How many people would know the official name of this bridge? Probably not many. It's actually the Queen Elizabeth II Bridge although, like the King Edward Bridge, it is slightly out of the way for something so central and most people probably don't think of it at all. It was opened on 6 November 1981, nine days before regular metro service from Haymarket to Heworth began.

In 2006, Nexus commissioned the artist Nayan Kulkarni to install a huge artwork, *Nocturne*, on the bridge. This saw the bridge being painted two shades of blue, while at night lights create patterns on the bridge.

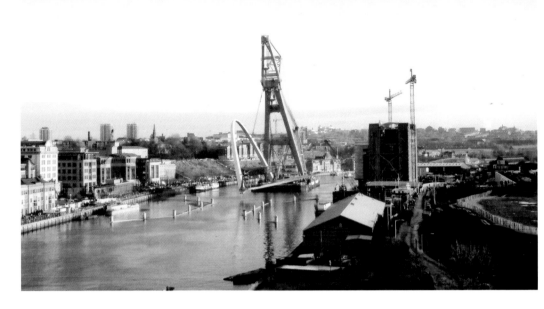

The Millennium Bridge being brought up the Tyne and lifted into place by Asian Hercules II, one of the world's largest floating cranes. The event took place on 20 November 2000 with the bridge being opened to the public on 17 September 2001. The author recalls there was some local opposition to the bridge and claims it would destroy a tradition of navy ships tying up at the quayside. In some ways its arrival was the final nail in the coffin of the previous quayside. Whether that is a good or bad thing is up to the individual.

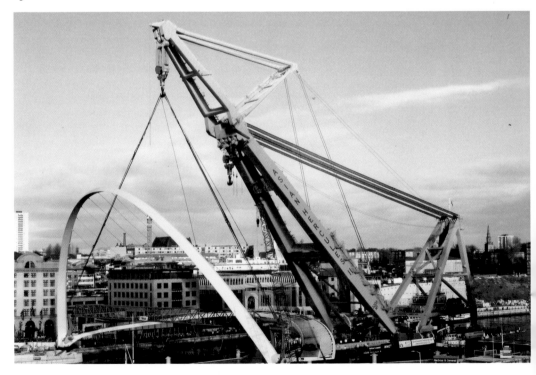